FIRST STEPS

Conserving Our Environment

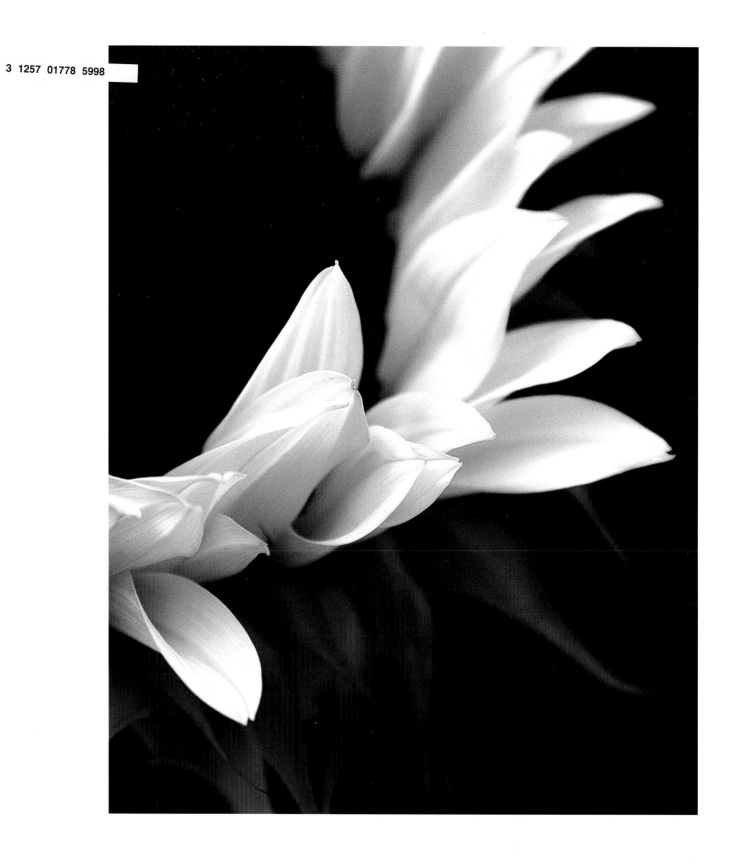

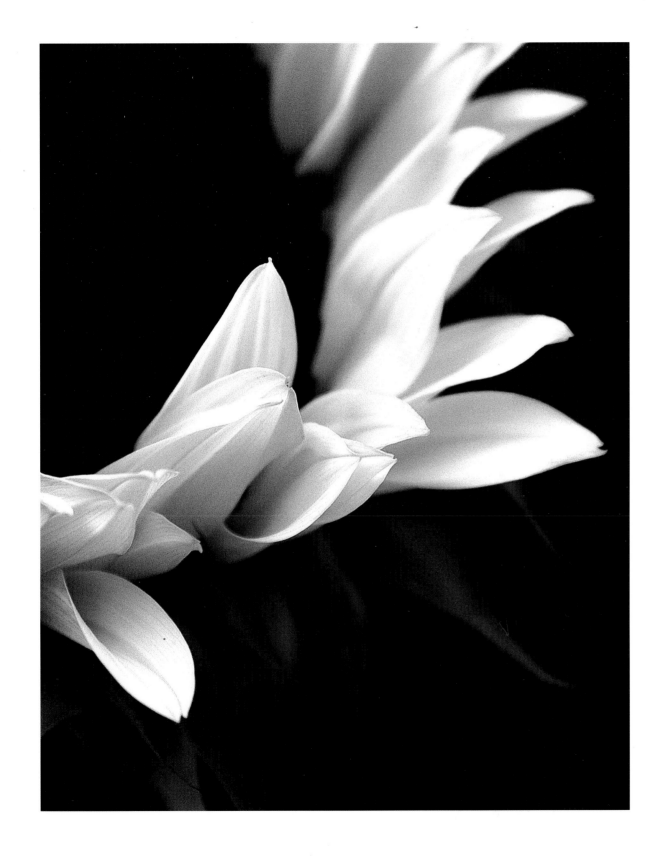
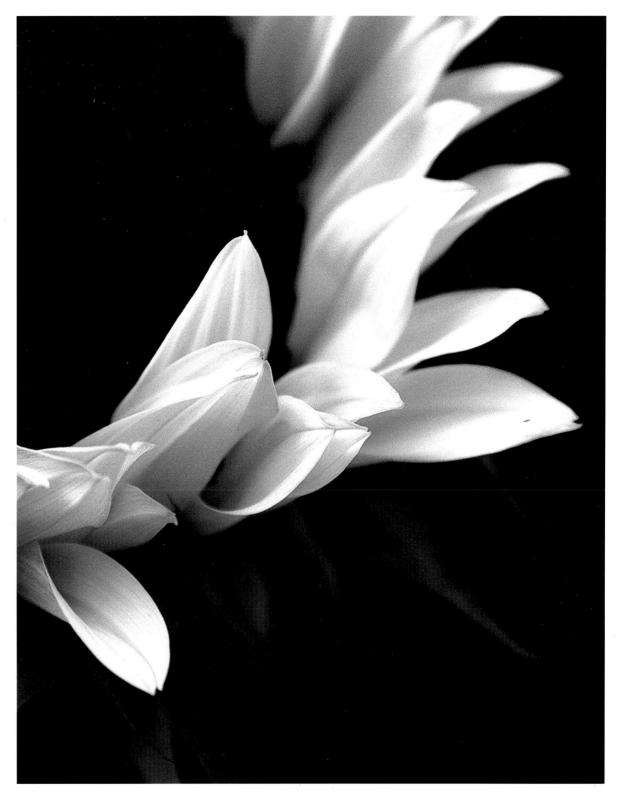

To Lindsey

for endless patience, support, love and inspiration

...and to Riley

for being good

WITH THANKS

I am indebted to many people who have given their help and expertise to put this book together.

Dr W Bryan Latham and Dr Michael Maunder and his team at the Fairchild Tropical Botanic Garden in Coral Gables have been an essential part of helping me understand some of the many issues in conservation and the preservation of bio-diversity. They also introduced me to the works of Professor EO Wilson — writings that provided a superb background for the themes in this book.

And to the many other authors and organizations whose published work provides the factual information contained here. Any errors or omissions in this book are solely my own.

For providing technical support and education in my many areas of ignorance, my thanks go to Scott Martin of On-Sight, Dudley Harris, Deborah Aaronson, Dan Tucker of Sideshow Media and Shannon Wilkinson of Cultural Communications.

For support and invaluable advice, Lyle Rexer, Robert Shamis and Chris Dickie.

Thanks to Cyril Ritchie, Stephen Perloff and Dominique Nahas for giving their time and expertise to make their contributions to this book.

A special thanks to The Hon Dr Michael Frendo as Minister of Foreign Affairs, Republic of Malta and to His Excellency Mr Victor Camilleri and Dr Hector Bonavia who, while at the Mission of Malta to the United Nations, sponsored the exhibit on which this book is based.

Many thanks to the United Nations and the staff in New York for making the exhibit possible. To the hundreds of people who attended and took time to leave complimentary comments in the guest book. This provided much encouragement to expand and seek to publish the work.

Finally, thank you for purchasing this book and making a contribution to the preservation of our environment

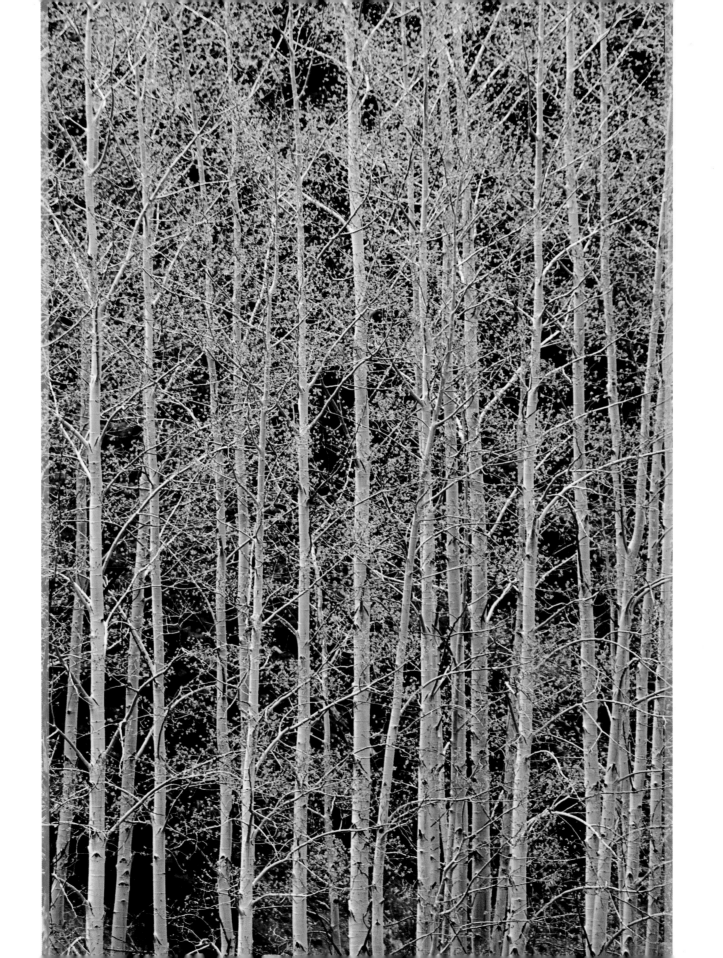

This book is printed on paper made from raw materials
certified by the Forest Stewardship Council
as sourced from sustainable forests

Layout: Kathy Rend. Cover Design: Patricia Fabricant

Published by Matte Press, New York
Printed in China

ISBN 978-0-9795071-0-6

FIRST STEPS

Conserving Our Environment

words and images by JOE ZAMMIT-LUCIA

Matte Press, New York

"Ultimately photography is subversive not when it frightens, repels or even stigmatizes, but when it is pensive, when it thinks."

—Roland Barthes (1915-1980)
Camera Lucida

*"A great poem can make as much difference as three volumes
of scientific analysis or a piece of legislation"*

—Thomas Lovejoy
President, H John Heinz III Center for Science,
Economics and the Environment

images of progress

Managing our deteriorating environment while encouraging continued development and eliminating poverty is one of the greatest challenges for the 21st century and beyond.

The fact that climate change, environmental deterioration and destruction of habitats and species have all picked up speed is no longer up for serious debate. We face choices. These choices are about science, technology, economics, social change and, more fundamentally, about our values — what we believe it means to be human beings entrusted with the ultimate stewardship of our planet.

We all have a growing awareness of the need to preserve the world around us. The search for new ways to encourage continued development while managing its impact on the environment has become a focal point for our society. In countries like China, cities such as Shenzen, which achieved its dramatic economic boom at the cost of great environmental damage, are no longer considered places to emulate. In developed countries, a modern lifestyle is becoming synonymous with an environmentally conscious lifestyle.

But maybe the biggest success has been the fact that environmental issues today have a significant effect on voter behavior. It is no longer possible for politicians to ignore the environmental effect of their choices.

I have always been interested by the extent to which artists can use their craft to influence opinion and sway public policy. Literature, painting, drama, cinema and other art forms have a long history of successfully influencing political issues and questions of public policy.

In the environmental debate, photography has, perhaps, been at the forefront of artistic engagement with the issues. Nature photography and environmental photojournalism have brought us face to face both with the beauty of nature and with the damage that we wreak. This book seeks to continue that tradition by engaging the viewer through a combination of words and images.

We are bombarded daily with negative news and images that attempt to capture attention by shocking the viewer through a kind of edgy voyeurism. I believe that we are all becoming adept at blanking out the negative — a protective mechanism that allows us to get on with our lives.

In this collection, my aim is to avoid the shocking while creating images that try to go further than a documentation of natural beauty. Is there some way of pushing environmental photography beyond its two traditional legs of nature photography and environmental photojournalism?

In attempting to find a path of emotional engagement while tempting viewers to pause and reflect, I have found the words of French post-modernist writer Roland Barthes quoted on the previous page to be highly inspirational.

My aim is to celebrate the initial progress that has been made in conserving our environment while drawing attention to some of the many issues still to be addressed. I hope this might persuade some readers to participate in environmentally sustainable development and to preserve the world around us and all species that make it their home. Enjoy the journey.

—Joe Zammit-Lucia

preface

united we stand

Environmentalists of the world, Unite! You have nothing to lose but your tendency to give conflicting messages.

Nations of the world, Unite! You have nothing to lose but your future .

I came upon Joe Zammit-Lucia's striking and content-full photography at the exhibit he put on at the United Nations Headquarters in New York in early 2007. As a person working for sustainable development (shouldn't we all be?), my attention was caught by the subtle way Zammit-Lucia's artistic approach enabled the spectator to « feel » the three dimensions of sustainable development, namely environmental, economic and social.

It seemed to me particularly appropriate that the exhibit should be at the UN, for in today's world there are precious few environmental, economic or social problems that respect frontiers. We can not approach, let alone solve, most of today's dilemmas in a framework of the primacy of national sovereignty. Westphalian concepts have long since been overtaken.

Only multilateral and multi-sectoral cooperation will enable us to find — conceptually and operationally — the solution to today's world problems. The exponential growth of world population over the past century has raised all world problems to unforseen levels of complexity and intractability.

Apart perhaps from the spread of nuclear weapons, Climate Chaos (the now preferred term — climate change having already morphed to nearly uncontrollable levels) is probably the number one issue we have to solve collectively. For this to happen, the United Nations is the irreplaceable forum, for only talk-talk-talk can lead to action-action-action. I therefore hope that wise heads at UN Headquarters — and at all major UN centres around the globe — will offer further oportunities for visionaries like Zammit-Lucia to help us open our eyes and our minds to what the world is really like, and why we have to preserve it.

In this book, Zammit-Lucia inspires us to move from first steps to taking some giant steps forward. We only have one world, and it's ours to waste or to conserve. If we unite, we will amaze ourselves with what we can achieve.

—Cyril Ritchie
Chairman, Environment Liaison Centre International (ELCI)
Geneva, Switzerland

We are addicted to consumption.

The industrial revolution brought wealth and development to many countries. It gave us an appetite for consumption that has grown unabated in the developed world. We have exported the idea of almost limitless consumption as an aspiration for developing nations.

In the process we have destroyed much of what we consume. Yet, until recently, we have been almost oblivious to the damage we cause to the environment. As if in a consumption-fueled daze, we have continued to seek more and more while using up most of nature's resources.

Consumption is the new opium of the developed world. Weaning ourselves off it is the difficult journey on which we have just embarked.

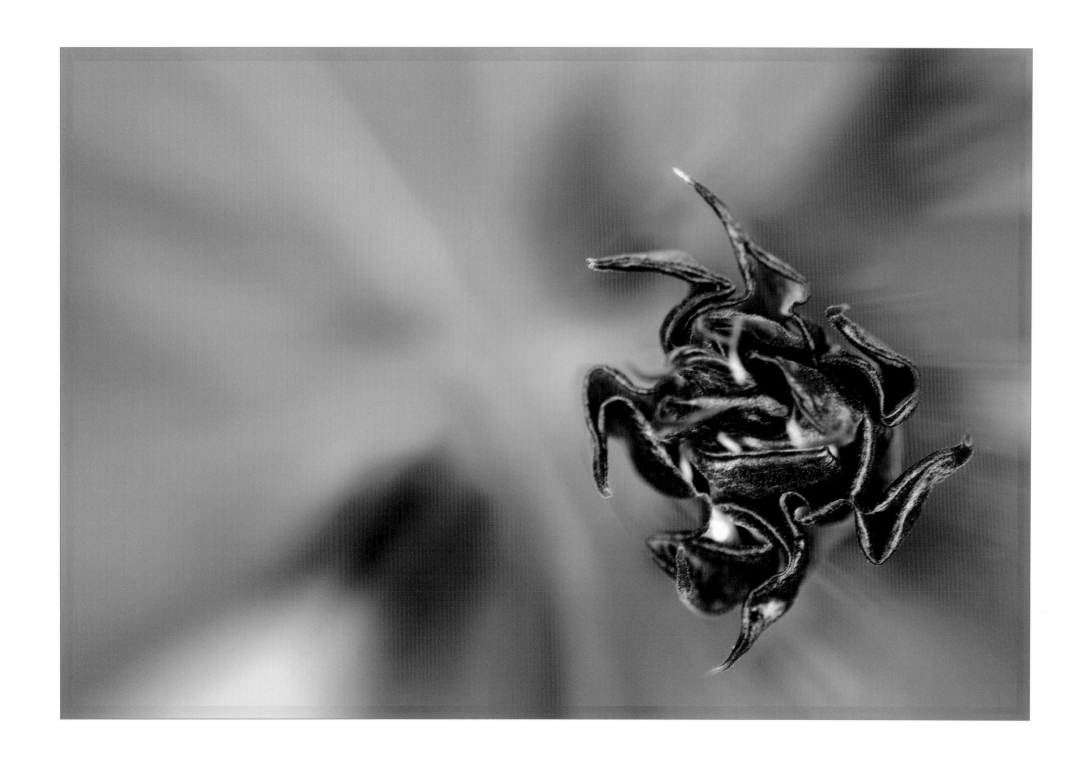

introduction

of what to appreciate

Konrad Lorenz, the Nobel Prize-winning animal behaviorist, once wrote that *we* are the missing link between the animals and human beings. While gifted with an intelligence to understand and interpret the world around us, and to record and supposedly learn from our own history, somehow we cannot seem to avoid the folly of war, or of intolerance, bigotry, or religious and racial tribalism.

And we cannot seem to avoid what most animals innately avoid: befouling our own home. Our short-term thinking in ravishing the only home we have — through creating pollution, through deforestation, through the decimation of many plant and animal species, through the threat of global warming — will bring us long-term misery.

Too often — from the ATV rider racing through ecologically sensitive areas to our own government, which seeks to enrich its corporate friends with oil, ore, and timber leases in federally protected lands — we act solely as exploiters of the land rather than as its stewards.

And yet, there is progress. There are successes, numerous small ones that awaken us to the possibility of slowing the pace of destruction, of preserving what remains, of re-establishing what has been lost. Through his photographs, Joe Zammit-Lucia reveals what is at stake. Rather than the now almost ubiquitous views of acid lakes, smog-filled skies, and toxic landscapes, Zammit-Lucia has taken a different tack.

The great social documentary photographer Lewis Hine once said, "There were two things I wanted to do. I wanted to show the things that had to be corrected; I wanted to show the things that had to be appreciated." Zammit-Lucia's photographs are *about* what needs to be corrected, but *of* what needs to be appreciated. He celebrates those small successes that engender hope for a larger transformation in our thinking and our behavior. And he does so through images that engage the eye, provoke the mind, and quicken the heart.

Photography has played an important role in conservation from its earliest decades. Carleton Watkins's pioneering photographs of Yosemite in the 1860s convinced a Congress skeptical of reports of its natural wonder of the accuracy of those reports and was a key element in Congress's establishment of the National Park system.

Most people do not now know that many of Ansel Adams's widely seen images of our majestic wilderness were made with the express intent to support the conservation of those areas. Zammit-Lucia's soaring and stately images of trees stem directly from Adams's tradition of pure seeing. It is here that photography in service of conservation works best: when our eye is arrested by the artistic image, when esthetic delectation impels us to practical thought.

This is the case again and again with Zammit-Lucia's photographs — of delicate and exotic flowers, of bicycles and cooling towers, even those of suburban development and urban concentration. A cacophony of color enveloping a series of small junks almost hides the clean, white lines of cabin cruisers belonging to the new wealthy in the harbor of some Asian megalopolis whose futuristic blue towers rise into the looming clouds.

In one particularly compelling image, rays of sunlight dramatically pierce the clouds hovering low over a vast expanse of sea while a lone ship bobs precariously on the waves. Yet technology has changed the rules. This could be one of those ships whose vast trawling nets are depleting endangered species of marine life.

Like Robert Glenn Ketchum, whose photographs of threatened landscapes in the Alaskan wilderness and elsewhere can be literally breath-taking, Zammit-Lucia stops us dead in our tracks with two gorgeous, paired images of a lone tree standing sentinel over row upon row of cultivation. In one image the burnt orange of the fields shimmering in the glow of the setting sun vibrates against the pink of the horizon as it melds into the darkening blue of the evening sky. In the other, striations of shadow alternate with the lush greenery of fecund plants beneath the clear light of a mid-afternoon sun. But all is not as it seems. As Zammit-Lucia points out, this tree is a sole survivor of the once vast Sherwood Forest in Nottinghamshire, England. It is a revelation as surprising as the conclusion of an O. Henry story.

When Eadweard Muybridge made his famous images of human and animal locomotion at the University of Pennsylvania between 1884 and 1887, he brought animals from the Philadelphia Zoo to his studio to photograph them against his gridded background in order to make studies for scientists and artists. There was no particular interest in the personalities of the animals, just in how they moved. James Balog took wild animals out of their environment and into the studio for his 1993 book, Anima. In that work and others, Balog let us see these animals in a different way — and he created pictures, balancing the frame of the image in a dynamic way.

Zammit-Lucia modifies this strategy, most often presenting the animals he photographs against a black background. The light seems not to be reflecting from their fur, feathers, or hides, but emanating from them. His rhinoceros seems, if anything, even more impossible than the fanciful creature imagined by Albrecht Dürer in 1515. The broad paw and lethal claws of his polar bear belies our first impression of cuddliness. His pink flamingo with its yellow eye might be some exotic alien fan dancer.

Yet Zammit-Lucia's photographs of animals do not take the easy path of anthropomorphizing them — although our close cousin, the gorilla, bores into us with eyes that reflect a self-awareness we can only vaguely comprehend. Rather Zammit-Lucia records in these animals a kind of sentience and a life force — what some might even call a soul — that we recognize as being hauntingly similar to our own.

With the rapid industrialization of China and India, among other countries, and continued population growth, pressures on our ecosystem will become even more severe. It is up to all of us to make a difference. Joe Zammit-Lucia has done his part to educate and energize us through his photographs and this book. I know he will be looking forward to the possibilities of what lies still ahead.

—Stephen Perloff

Editor, The Photo Review and
The Photograph Collector

Langhorne, Pennsylvania

land & sea

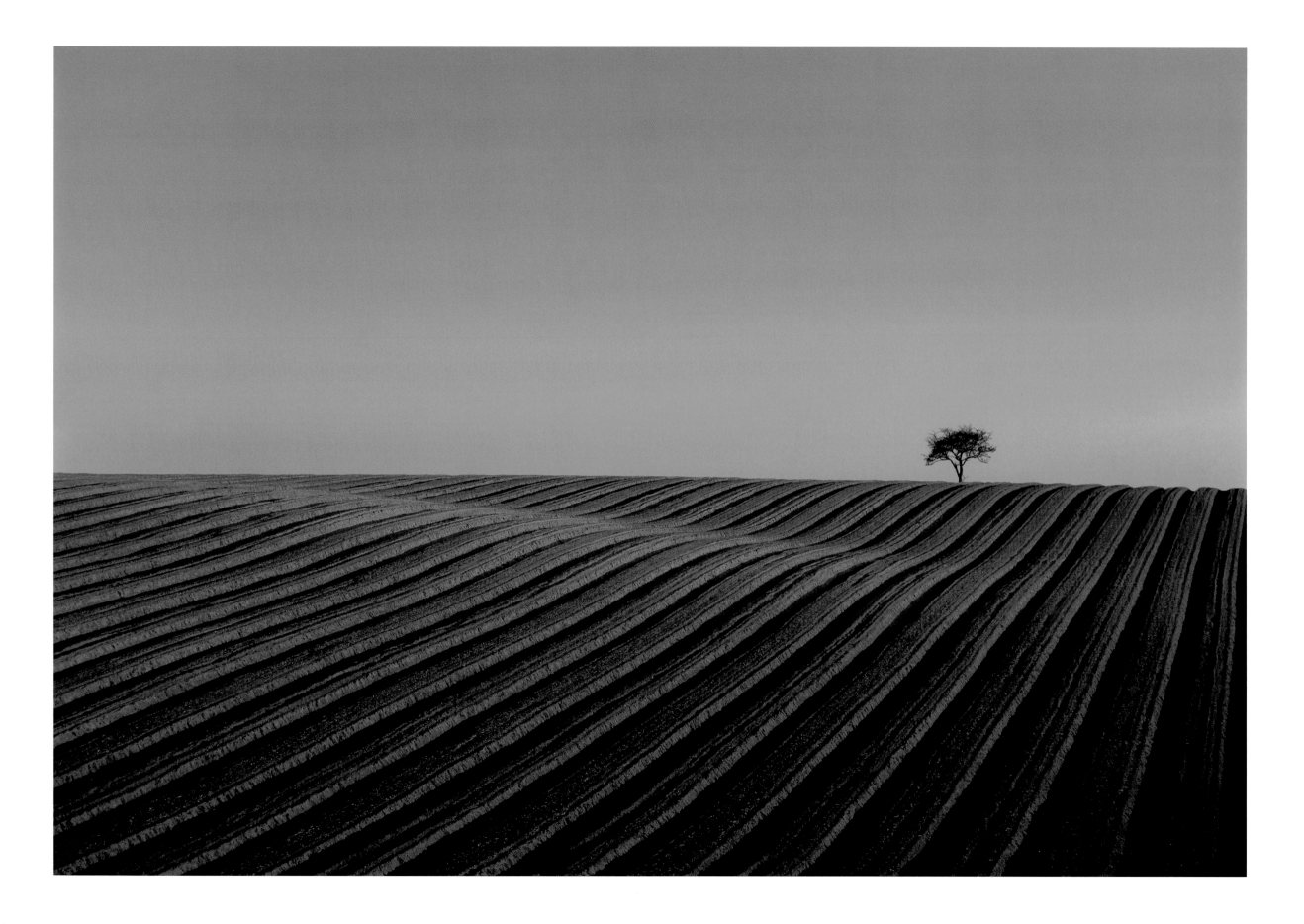

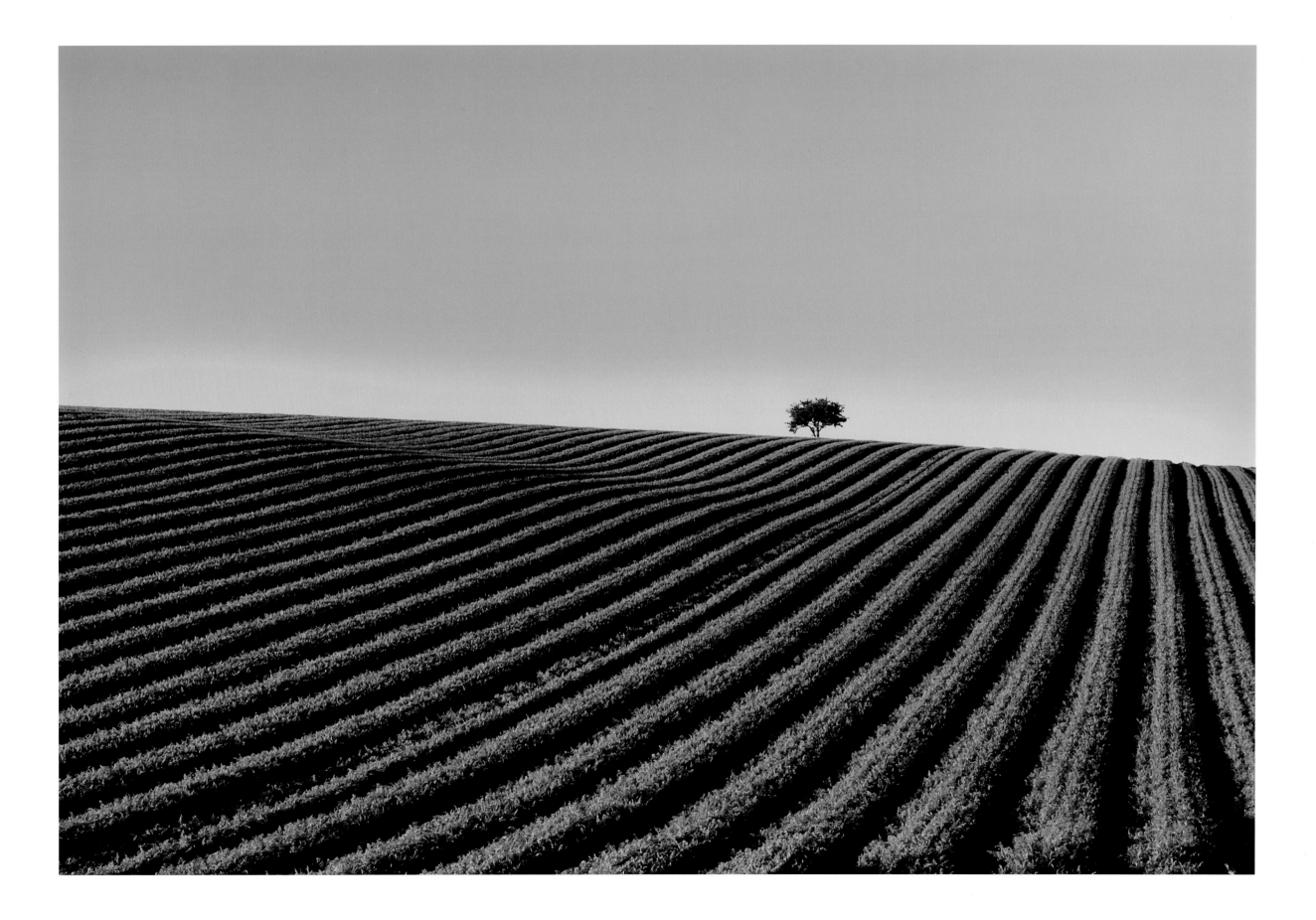

OUR WEALTH IN DECLINE

The wealth of our natural economy is falling. An index measuring the
condition of the world's forests, freshwater areas and marine environment
fell by a full thirty percent between 1970 and 2003.

PREVIOUS PAGES: Just One Tree — Autumn *The agricultural landscape shown once formed part of the mighty Sherwood Forest in Nottinghamshire, England.*
 Just One Tree — Summer *The sole surviving tree is a symbol of extensive de-forestation as forests and woods gave way to agriculture.*

For centuries forests and natural landscapes have given way to agricultural land. A drive across Europe today would fail to find any significant natural landscape except at northern latitudes unsuitable for agricultural development. The same is true of most of North America. Eighty-three percent of the Earth's land surface is today under some form of human influence.

A significant proportion of this loss of wild habitat has happened in the last century as population growth has driven demand for food and housing while new technology has enabled us to accelerate development. There is practically no wilderness left. Whatever remnants may still exist represent today's development frontiers.

The last several years have, nevertheless, seen significant positive progress.

In Europe, reform of the Common Agricultural Policy offers hope for the future. The program will no longer be the world's biggest monument to waste. New incentives will be geared towards encouraging land and animal husbandry, environmental protection and food safety.

The system of national parks, wilderness areas, wildlife sanctuaries, hunting preserves and so on, designed to preserve wide areas of natural habitat has become a worldwide phenomenon that continues to grow. The effect of national parks in increasing environmental awareness has been significant. More directly, the larger parks have a direct impact on species preservation. The joint Glacier National and Waterton-Glacier International Peace Park in Montana and Alberta have yet to see the loss of a single species.

Everywhere, there is growth in the amount of protected land area. The Brazilian government has created two new national forests. In Mexico in 2004 the government made the largest conservation land transaction in the country's history. Some argue that these efforts are insufficient. In Brazil, the ultimate goal is to preserve a mere ten percent of the tropical rain forest.

The creation of parks and reserves also raises issues of land ownership and of ways to balance the need and desire for protected areas against the needs of local people. In 2005 in Kenya, the status of Amboseli National Park was downgraded to a national reserve and control passed from the Kenya Wildlife Service to the Maasai people.

More encouragingly, there are increasing mechanisms by which wealth from developed nations can flow to developing countries for the purposes of conservation. Money raised by non-governmental environmental organizations in developed countries is now being used to acquire leases on tracts of land considered bio-diversity hotspots — habitats rich in important plant and animal species. These lands are preserved and managed for their natural habitat, providing local employment and a benefit to us all.

The next step is for governments in wealthy countries to start funding similar projects. Here again, we see a positive start. Debt-for-nature swaps form one financial vehicle that is gaining popularity. In 2006, facilitated by the Nature Conservancy, the United States agreed to cancel debt owed to it by Guatemala in return for the Guatemalan government making a commitment of cash and other resources to protect its tropical forest habitats.

The future of wilderness places seems more positive today than in the recent past. Increased awareness coupled with practical solutions has started a tentative recovery which, with our continued support, can grow and continue to be successful.

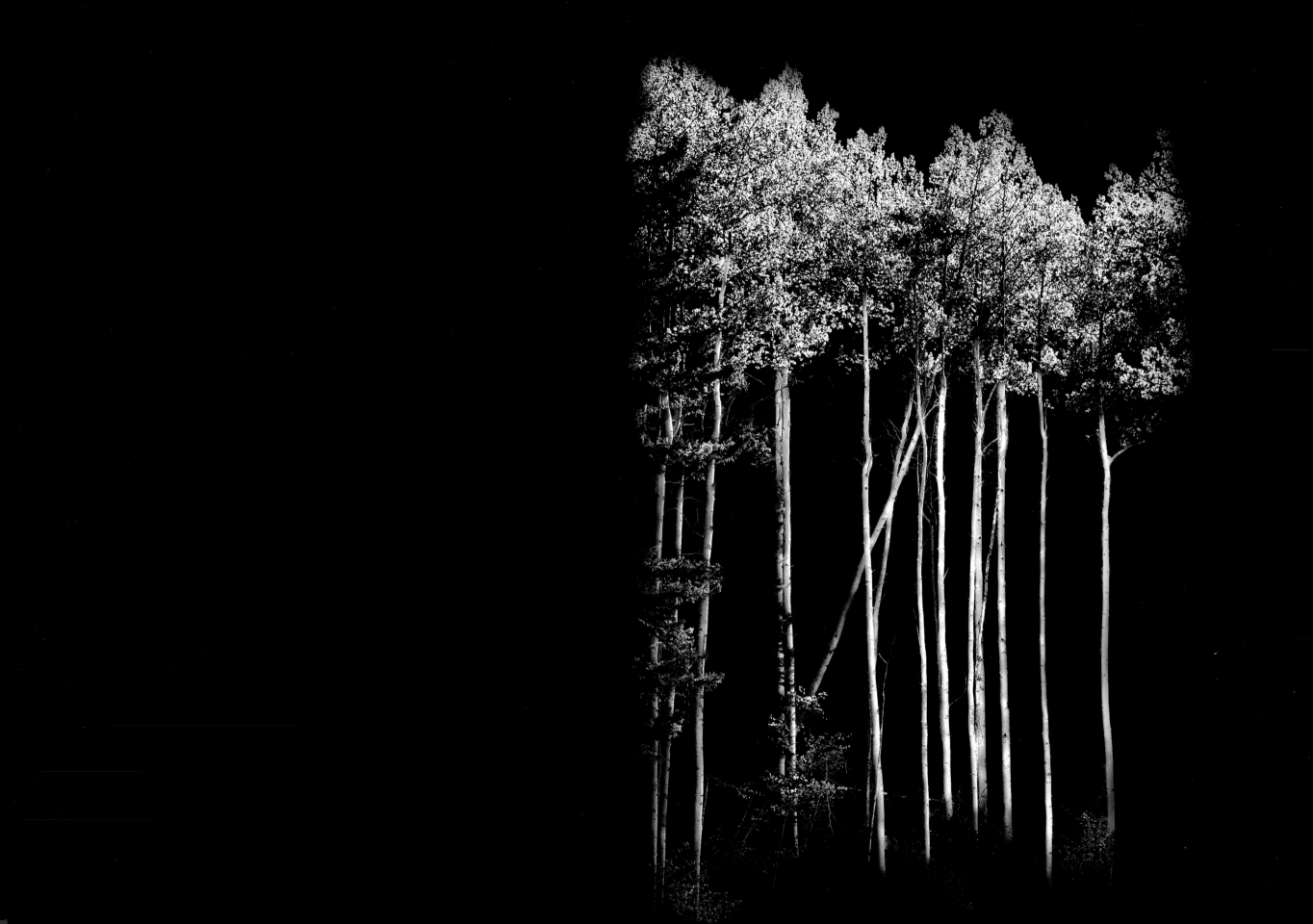

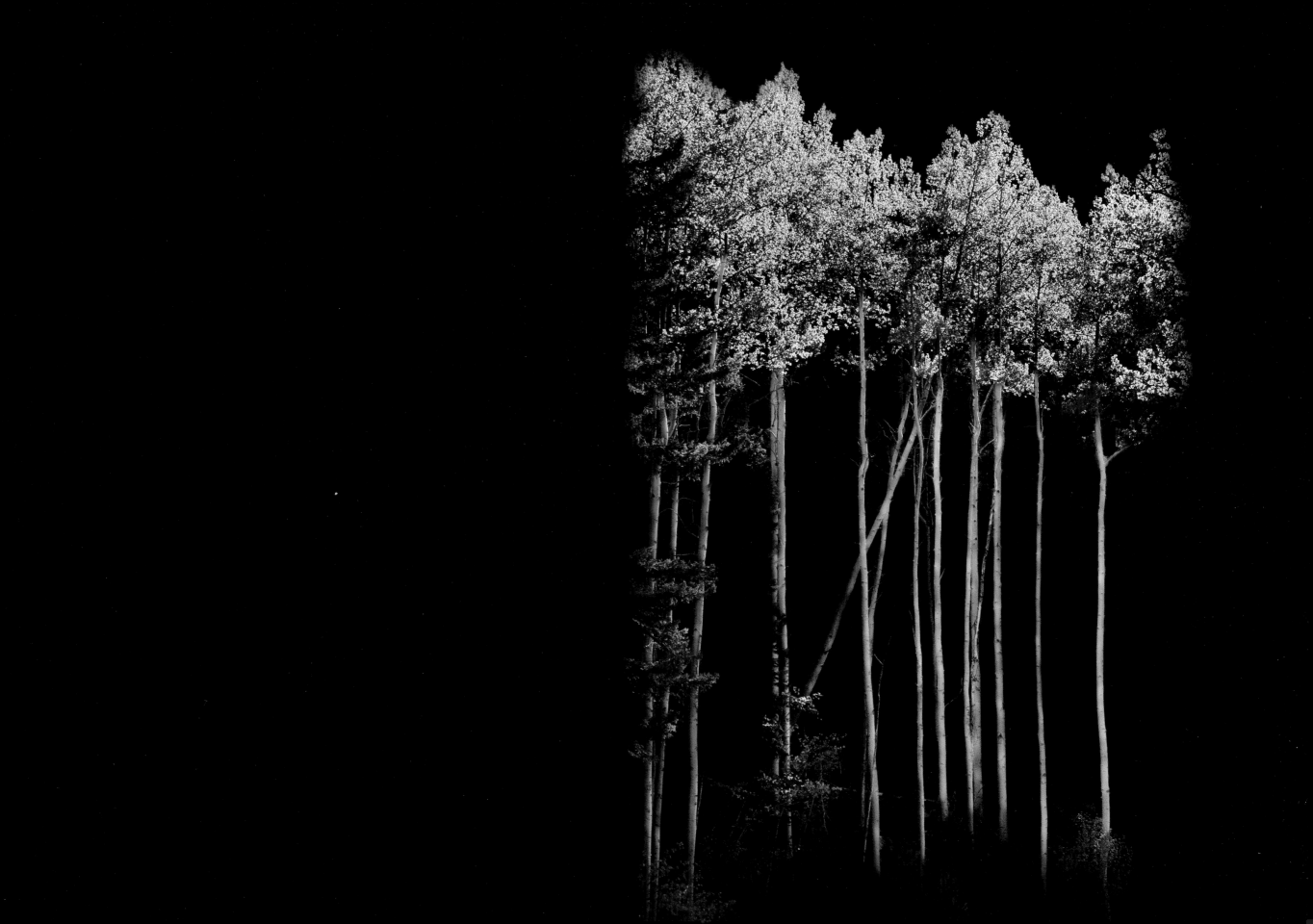

In the moist, tropical forests of Indonesia, eighty percent of forest cover has been committed to logging and replacement by oil palm and other plantations.

As demand for timber continues to increase, some have warned of continued damage both from forest clearing and consequent loss of habitat and from the wider effects of logging operations and wood processing.

But there has also been significant progress in afforestation projects and growth in sustainable forestry worldwide.

Trees have been planted across significant swathes of agricultural land creating forests for sustainable commercial use. In developed countries, most timber harvests are designed to minimize the environmental impact and to maintain the long-term productivity of the forest. In some forests, trees are managed for multiple uses including recreation and protection of the natural habitat.

The Forest Stewardship Council (FSC) provides certification of wood sourced from sustainable, well-managed sources and many builders and architects will now use only certified wood for building projects. This book is printed on paper from raw materials that are FSC certified as having been sourced from sustainable forests.

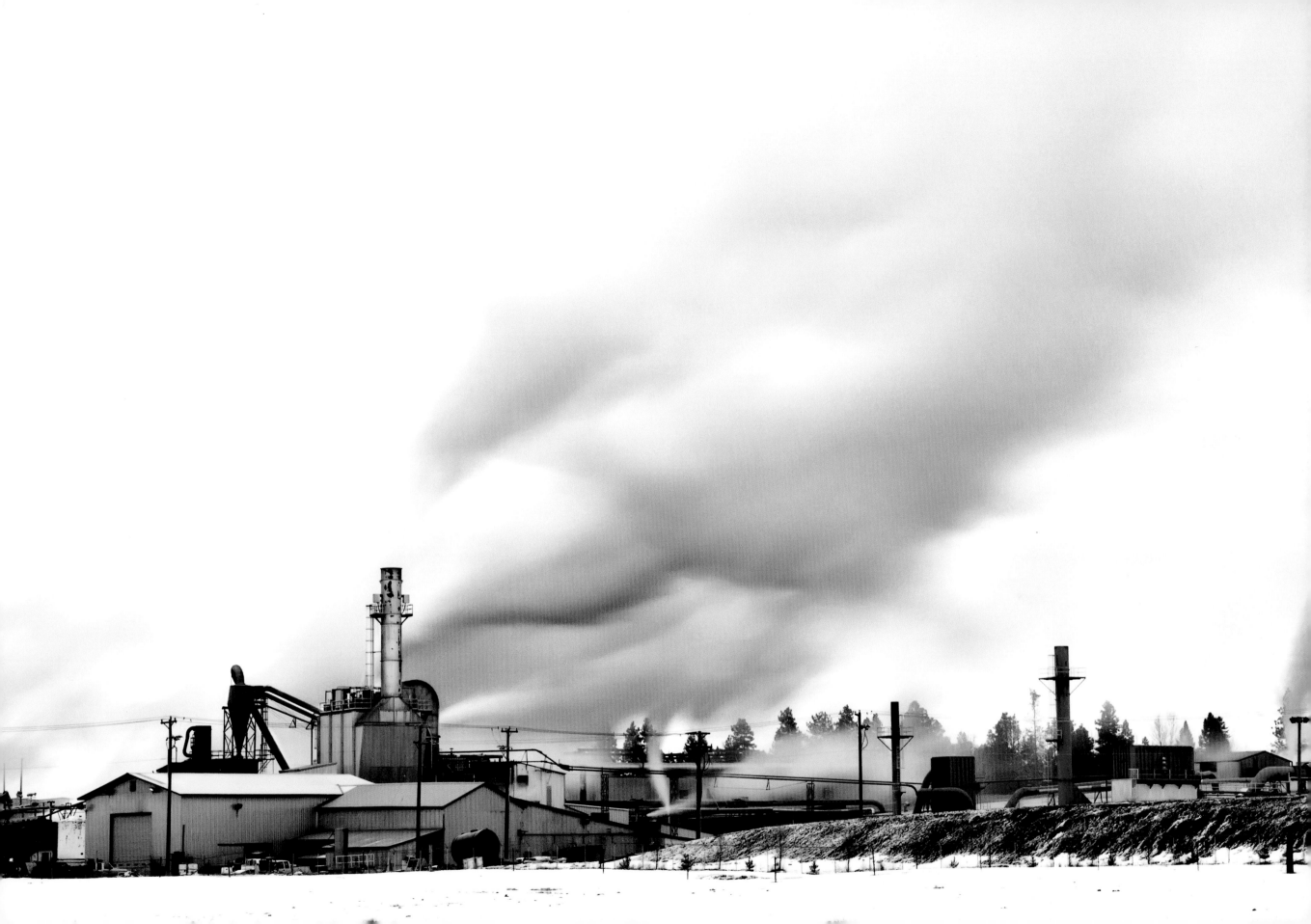

Restoration of damaged or destroyed forest landscapes to a near natural state is a challenging undertaking. The long time scales and high costs involved in undertaking large scale re-forestation means that, so far, most projects have been on a small scale. Nevertheless, there have been some notable successes.

In the Mediterranean, human beings have influenced, and depended on, their environment for thousands of years. Effective forest restoration projects in Southern Portugal today provide joint benefits such as protecting the habitat of the critically endangered Iberian Lynx while providing economic benefit to the local population through the production of cork and harvesting of forest products such as mushrooms.

In Kenya, re-forestation projects protect local species and habitats while providing immediate benefits to the local population in the form of forest products, fresh water and food.

In eastern Brazil, a Wildlife Fund for Nature (WWF) project is restoring the critically damaged Atlantic forests. While the work is done with consideration of local development needs, the habitat of threatened species such as the golden lion tamarin is being extended. The benefits of these new forests in terms of climate change may also open up additional sources of income for the local community through global carbon trading schemes.

In Scotland, a Forestry Commission project is restoring the largest native woodland in the country since medieval times. Providing recreation areas and a wide area of uplifting natural beauty, this project has brought to the local community a new sensibility about the human value they have gained from restoring the damaged environment around them.

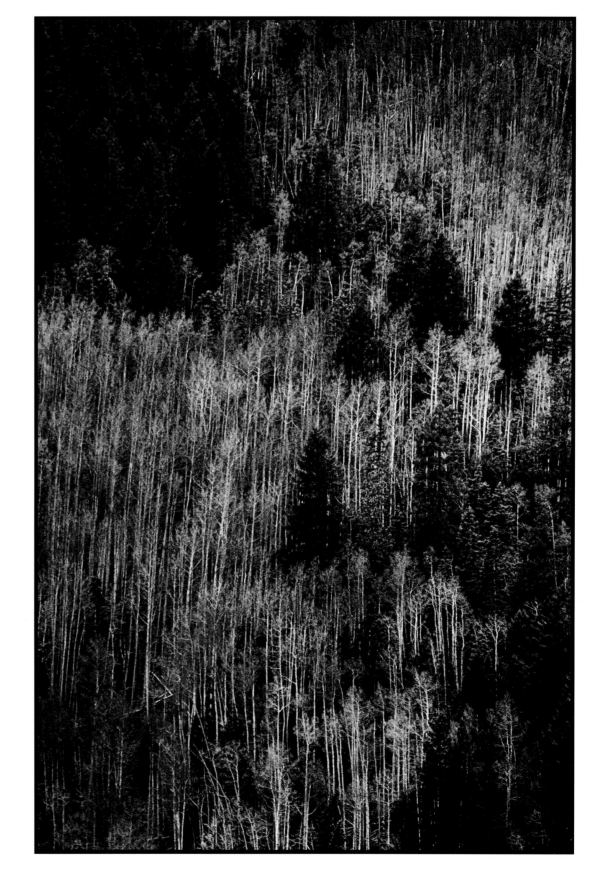

Aspens and Pines

The Placid sea lay shimmering
In a mist of blue,
From which the sky now drew
Its wealth of hue and colour;
One heard but the deep breathing of the ocean,
As it breathed along the shore in even motion.

There Where the Sea
—MARIE TUDOR

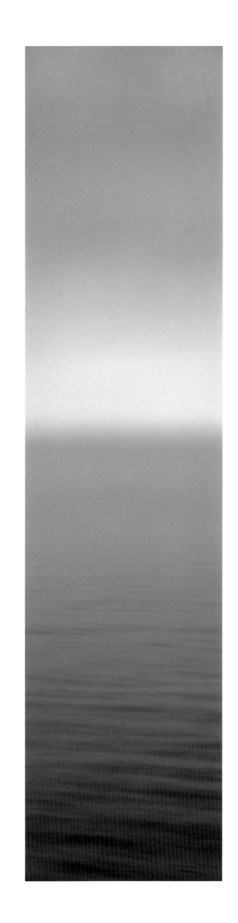

Sometimes the actions of small communities shine like a beacon illuminating the way forward for the rest of the world.

In the waters surrounding St Lucia, the fishermen of Sufrière agreed to set aside a third of their fishing grounds as marine reserves. Within five years, trap catches were up by between 46 and 90 percent. After seven years, fish stocks rose by five times.

In 1977, the local press in Goat Island in the North Island of New Zealand confidently predicted economic catastrophe when a two square mile stretch of local marine habitat was declared a no-take marine reserve. Today, the area is so rich in marine life that it attracts a constant stream of visitors, has a marine education center and a booming local economy.

These and other successes would make one think that communities everywhere would be rushing to follow these examples. Not so. Today, less than half of one percent of the vast oceans is protected from fishing. Attempts to create marine reserves are resisted tooth and nail by commercial and recreational fishermen alike.

It makes one wonder. What is it that enables small communities like those of Sufrière and Goat Island to act so effectively in what is clearly their own self-interest as well the interests of the oceans around them, yet prevents these same successes from being replicated when it is up to governments in supposedly advanced countries to effect the change? What has gone so wrong with our systems of democratic government that makes them so weak and ineffectual in implementing changes that are so manifestly in everyone's interest?

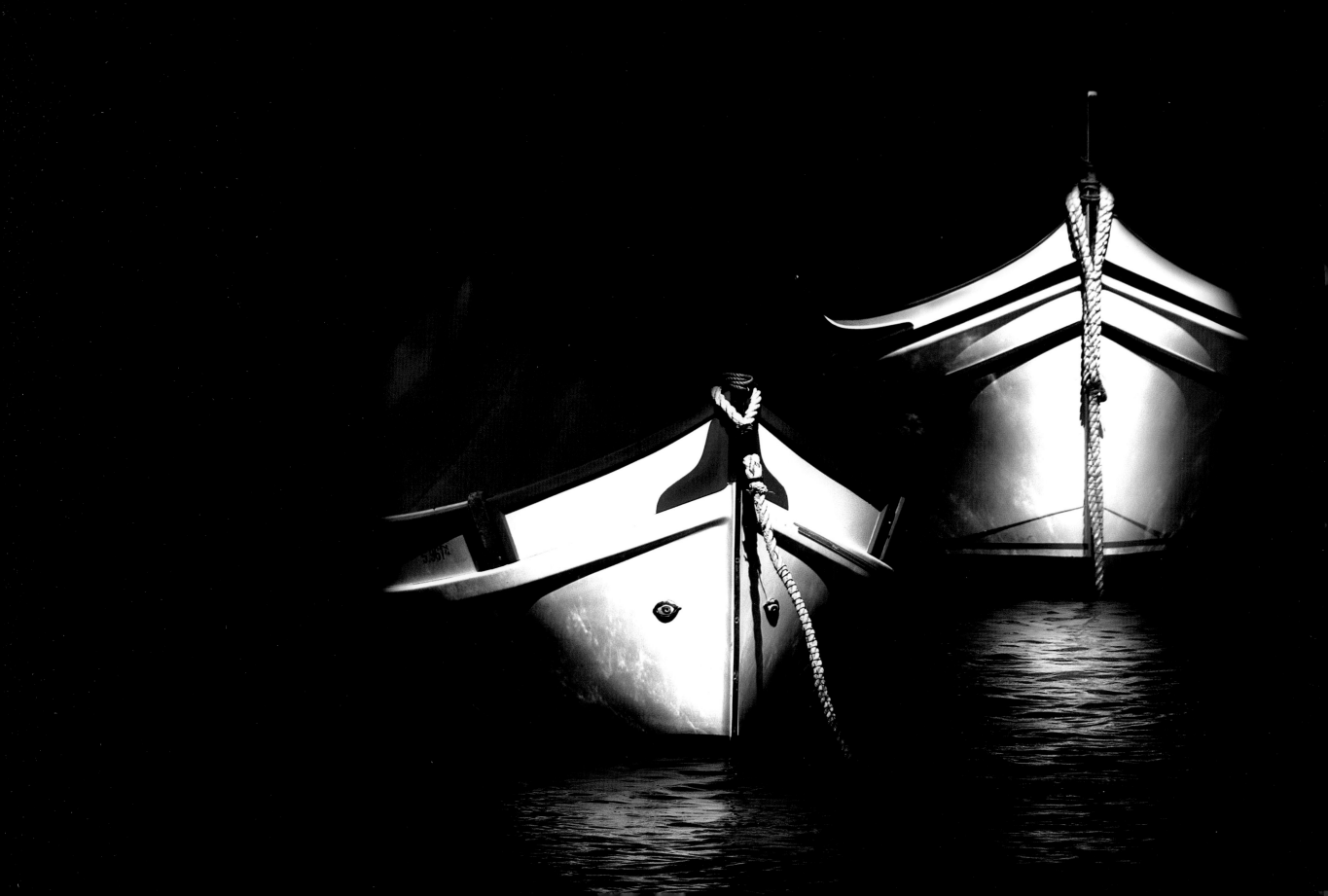

SOME SUCCESSES

The Marine National Monument in northwest Hawaii opened in 2006 as the largest marine reserve in the world.

Fish stocks and fish takes by fishermen have increased substantially since protection of the Mombasa Marine National Park in Kenya started to be effectively enforced.

Some thirty percent of the Great Barrier Reef is now a marine reserve.

The De Hoop Marine Protected Area in South Africa is a marine extension of a land conservation area. The combined reserve protects plant and animal species and has become a highly successful eco-tourism destination.

As fishing communities are increasingly starting to understand the value of setting aside significant swathes of no-take marine reserves, new opposition is emerging from recreational fishermen. Marine reserves can only be effective if protected from all forms of fishing - commercial and recreational.

Fish and seafood feed over one billion people worldwide.

This is part of what was nature's bounty. Once thought infinite, the bounty of nature provided us with a self-sustaining source of food and other services. But we have found ways to destroy these gifts almost irrecoverably.

For decades, over-fishing and deep-sea trawling practices have been the primary sources of depletion and extinction at sea. Wasteful fishing practices mean that for every ton of fish caught for food, tons of other fish are caught as 'by-catch' — tangled in nets and lines and killed only to be discarded. Think of it:

- for every 0.5kg of shrimp that is caught for food, between two and three and a half kilograms of by-catch are destroyed
- caught in fishing nets, 12 million sharks die each year — yes 12 million — hard to believe
- in 20 years, the female population of the Eastern Pacific leatherback turtle declined from 91,000 to 1,690
- 200,000 albatrosses are killed each year

And that's just the by-catch.

In the Mediterranean, twelve species of shark are extinct for any commercial purposes. The cod population has plummeted right across the Atlantic driving fishing communities to penury. The bluefin tuna population in the Mediterranean is about to collapse.

We believe that we can manufacture alternatives. Fish farming and aquaculture will replace our food sources. The reality is that the costs are much higher and the quantities can never match Nature's generosity. Aquaculture is a polluting activity that takes up resources that could have been better used in other ways.

We are increasingly faced with a choice — do we want food or do we want more money today?

Much is at stake. The fishing economy is worth $82 billion worldwide and is in danger of collapse. Large communities will be deprived not only of their livelihood, but of the food on their children's table while swanky restaurants in Manhattan, London, Tokyo and Shanghai continue to serve poached Atlantic cod, tuna sushi and Chilean sea bass.

Progress continues but remains slow.

The most damaging deep-sea trawling practices are being banned in most countries. Fishing quotas are painfully negotiated in multi-lateral agreements. And the growth in marine reserves might yet allow fish populations to recover if agreement can be reached quickly enough.

Enforcement remains an issue. Approximately 60,000 tons of bluefin tuna are probably caught annually in the Mediterranean as against a quota of some 30,000 tons.

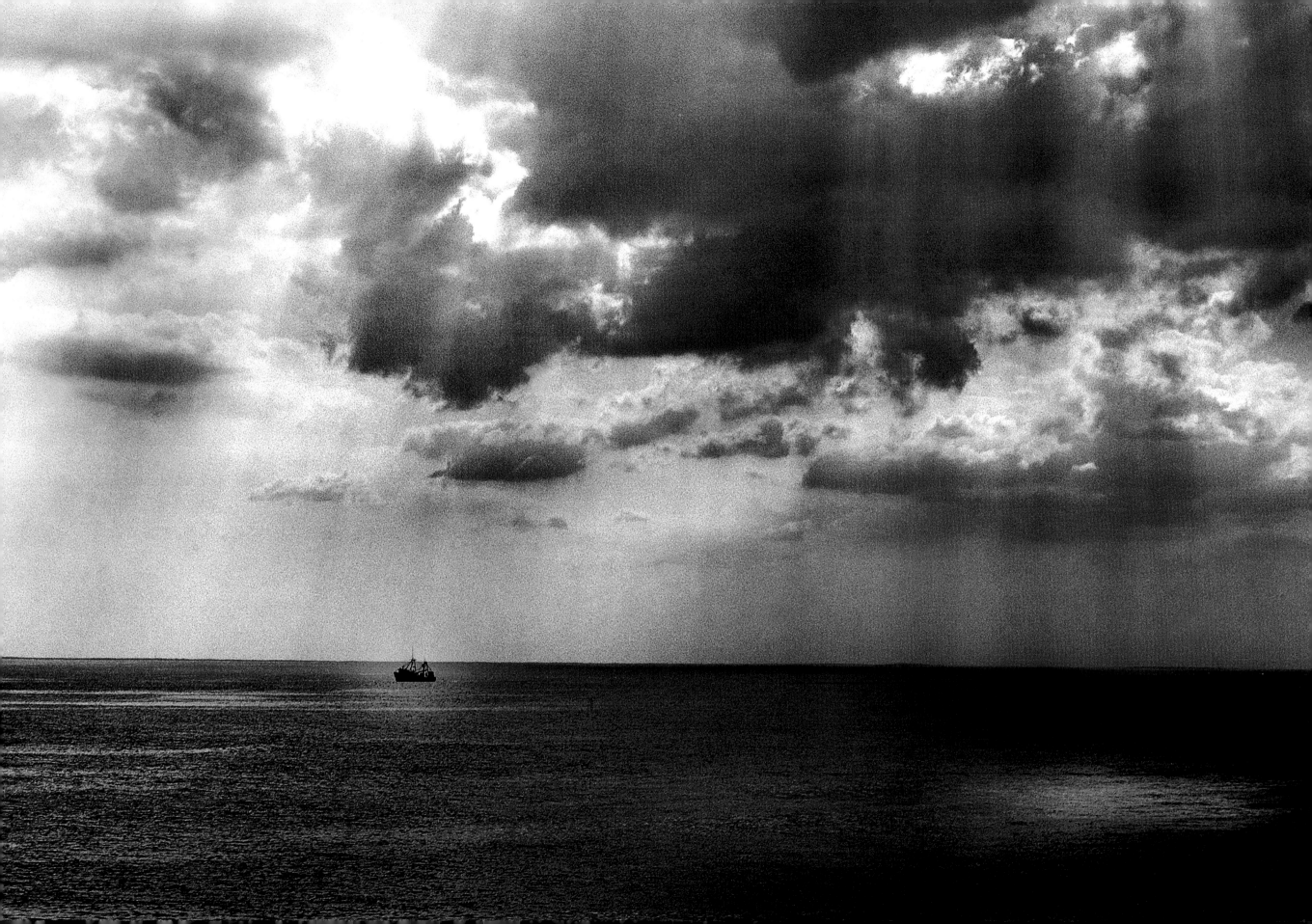

SOME SEAFOOD
TO ENJOY

Arctic Char

Pacific Cod

SOME SEAFOOD
TO AVOID

Dorado (mahi-mahi)

Atlantic Cod

Sardines

Grouper

Striped Bass

Monkfish

Tilapia

Farmed Salmon

Clams

Red Snapper

Mussels

Swordfish

Farmed Oysters

Chilean Sea Bass

Bigeye or Bluefin Tuna

Caviar

Visit www.seafoodchoices.com and www.msc.org

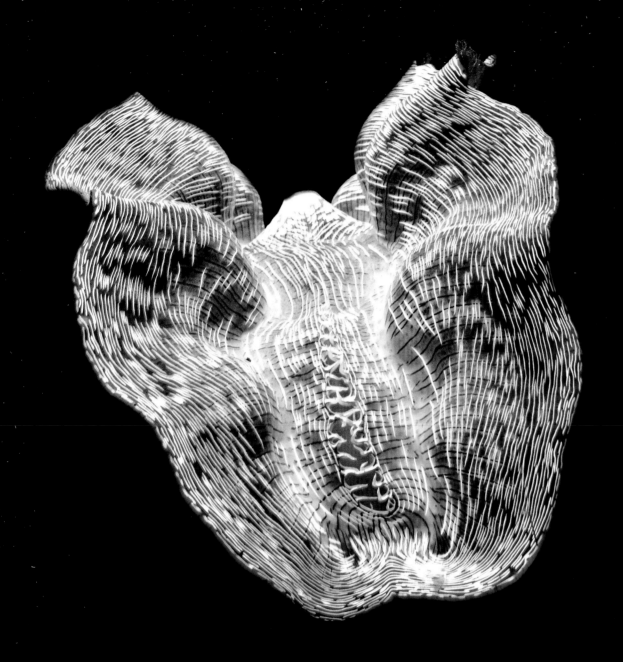

All earth's full rivers cannot fill
The sea, that drinking thirsteth still

Sheer miracles of loveliness
Lie hid in its unlooked-on bed

—Christina Rossetti

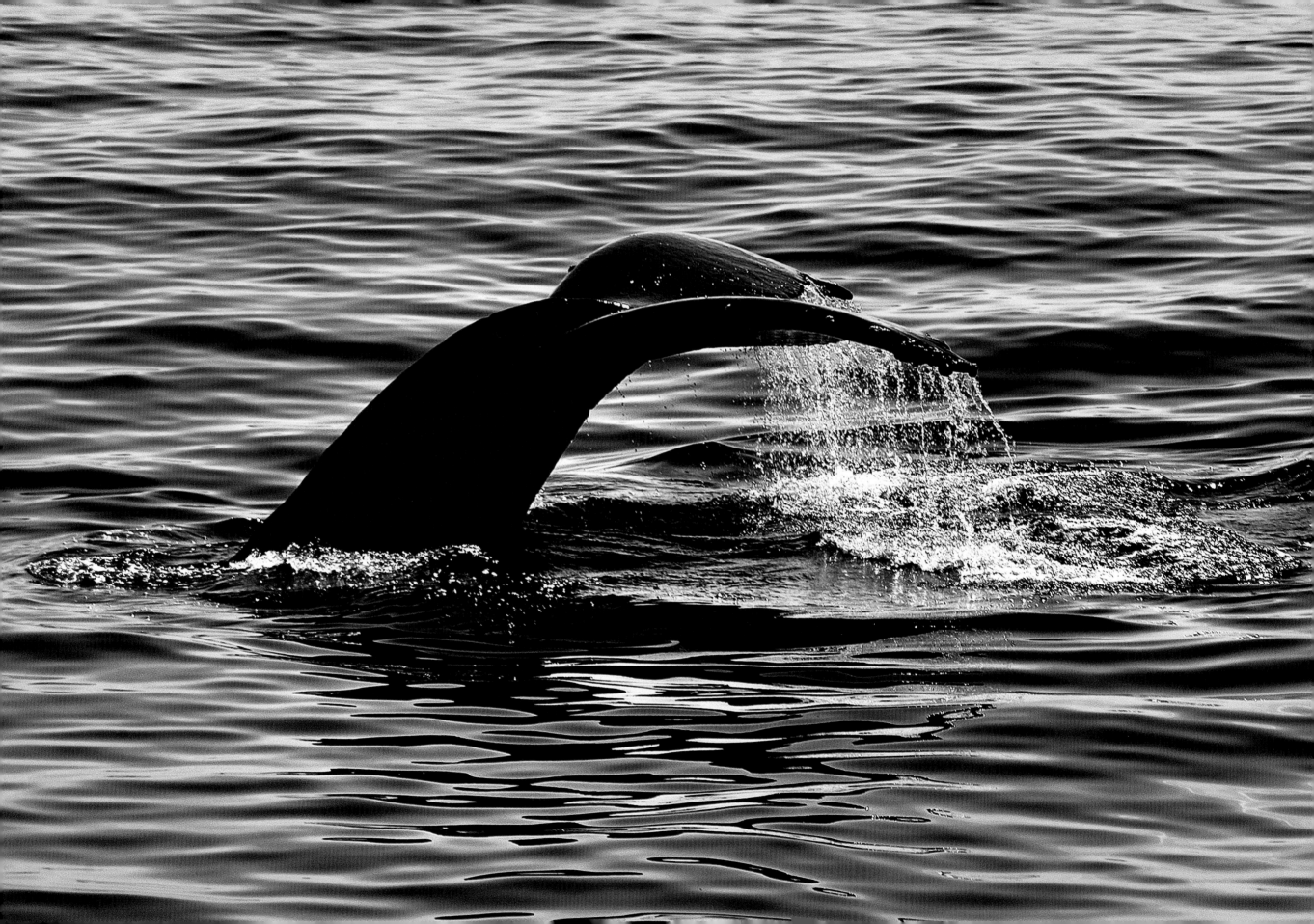

The work of the International Whaling Commission is, perhaps, one of the most striking successes of international co-operation.

We have come a long way since economists' reports in the 1970s argued that the most economically efficient way forward was to hunt whales to extinction and then re-tool the fleet for other purposes.

A moratorium on commercial whaling has now been in place for over 20 years. The population of some whales has recovered to an extent that some countries feel that it should now be permissible to re-introduce limited hunting.

There is, of course, continued debate that is often acrimonious. Some countries opt out of the moratorium while others find ways round it. The true state of whale stocks remains a subject of discussion. Some believe that whales are special creatures that should not be subject to hunting by wealthy countries with no economic dependence on whale products.

Whatever one's individual view and in spite of the ongoing heated exchanges, the dramatic shift in the nature of the debate over a period of twenty-five years or so is testament to the outstanding success of this worldwide co-operation.

sharing

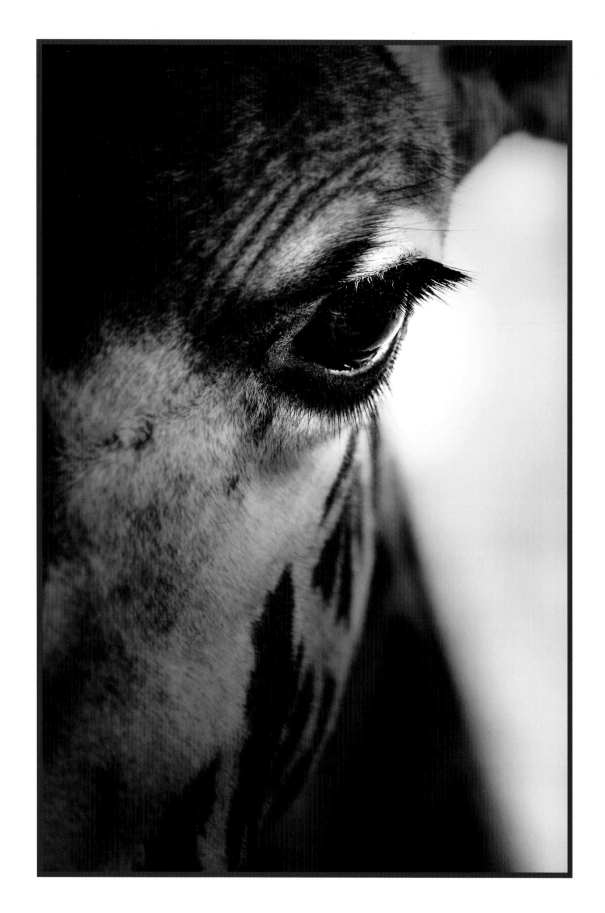

First they ignore you.
Then they laugh at you.
Then they fight you.
Then you win.

—Mahatma Gandhi

So why does it matter? Should we care?

One in four of every mammal species and one in eight of every bird species are threatened with extinction. Nearly 300 species of tree are similarly endangered. Overall, over 16,000 species are on the threatened list. And that's just what we know about.

As human beings we have found ourselves incapable of sharing the earth with other species, except those we have chosen to tame and intensively farm for our own purposes. The process of displacement is rapid. In Australia, sixteen of the 263 native mammals have vanished in the short time since the arrival of European settlers.

Extinctions happen when we destroy habitats as we appropriate land for building and farming. It happens when we introduce exotic species of plants and animals that displace native species. It happens because we pollute and we over-harvest for short term, unsustainable gain.

So what? Why does it matter that species are vanishing by the dozen? Is this not merely biologists' sentimentality?

Maybe not.

Looking at it purely from the perspective of human economic self-interest, the rate of damage to habitats and species is a frightening prospect. It has been calculated that the 'natural economy' (fish in the sea, fresh water filtered into watersheds, plants providing coastal protection against floods, self-sustaining natural food sources, and so on) provides us with services worth about $20 trillion. If we were to eliminate this natural economy, it is not clear that we could ever generate enough wealth to replace these services by 'manufacturing' alternatives because the costs rise exponentially the more of it we have to replace. Our own decline would almost certainly be the final consequence. We reap what we sow.

But even on a much smaller scale, every time a plant species is lost, do we wonder whether that could have been the source of an important medicine for our children? Every time a habitat is damaged or an animal species is hunted to extinction, do we wonder how that will alter the ecosystem, potentially leading to direct consequences on our food chain, water supply, susceptibility to natural disasters, and so on?

Maybe there is also something deeper that makes us pause.

It has been said that man does not live by bread alone. Are we comfortable with the prospect of living in a world with ever diminishing natural beauty; vanishing space for relaxation or recreation; no more tigers or polar bears or eagles to be seen anywhere except, if we're lucky, as glorified pets in a few manicured nature reserves? Are we happy to live up to the label that some have given to the human race — Earth's 'serial killer'?

Apparently not.

As awareness increases of the damage being done around us, the waves of change have started. Today they may still be no more than ripples in the sea of destruction, but they are noticeable and growing daily. No major corporation can operate today without an environmental program — sometimes a meaningful one; sometimes merely a fig leaf for corporate activities. The economic success of environmentally friendly industries and products continues to rise. No politician can expect to get elected without explaining his or her environmental position to the voters.

Is the rhinoceros resigned to its fate?

It is possible that the rhinoceros will be extinct in the wild within the next fifty to a hundred years. Intensive hunting and poaching for rhino horn, much prized in traditional Asian medicine, has driven down the rhino population and may continue to do so in the coming years.

In Swaziland, the white rhino had become extinct. However a program of careful re-introduction has been successful. The population has re-established itself and has grown to such an extent that some controlled hunting may even be possible.

For the Sumatran rhino, on the other hand, the die seems cast. The population in the wild has dwindled and re-introduction programs are unlikely to be successful. The species is in unstoppable terminal decline.

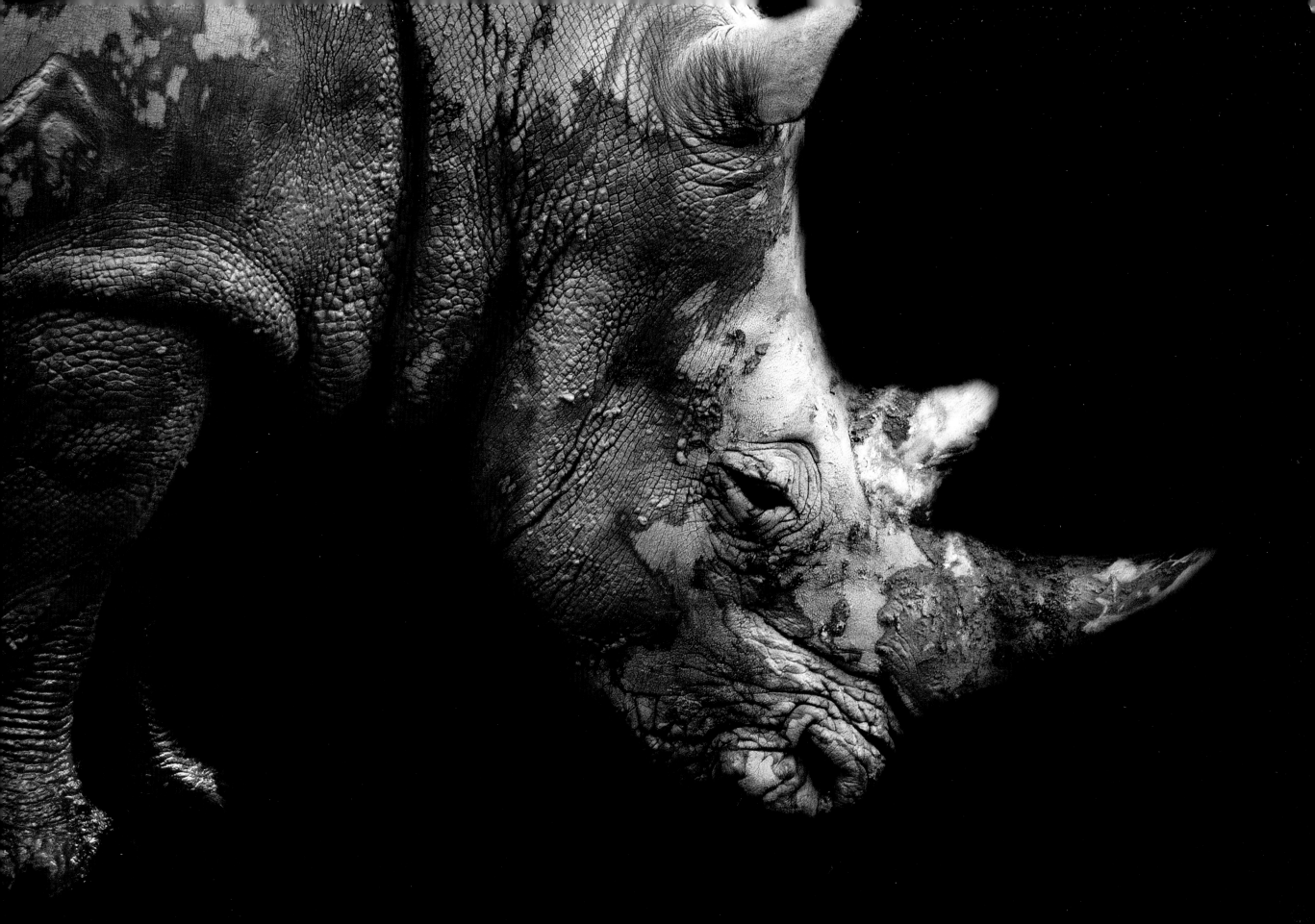

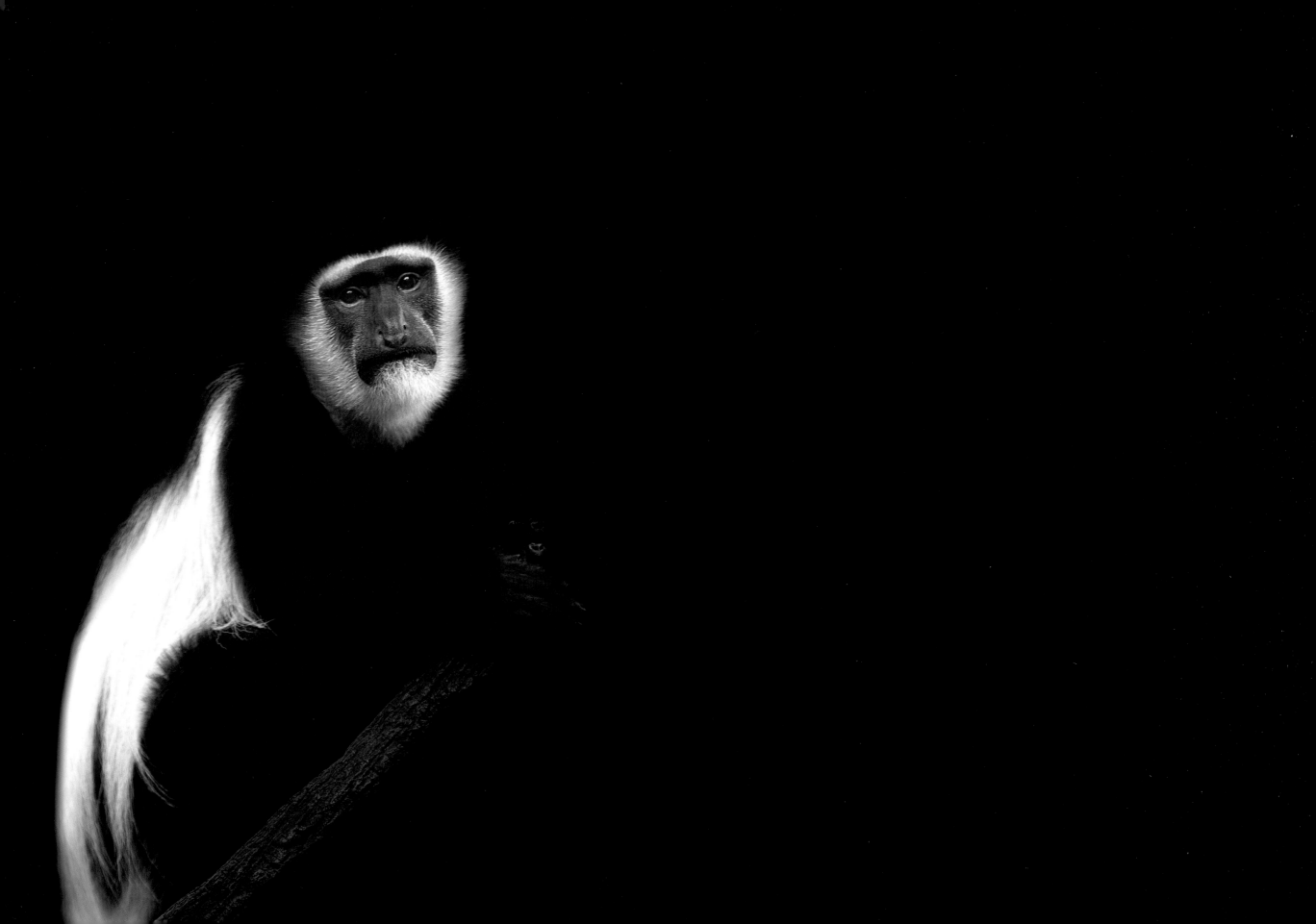

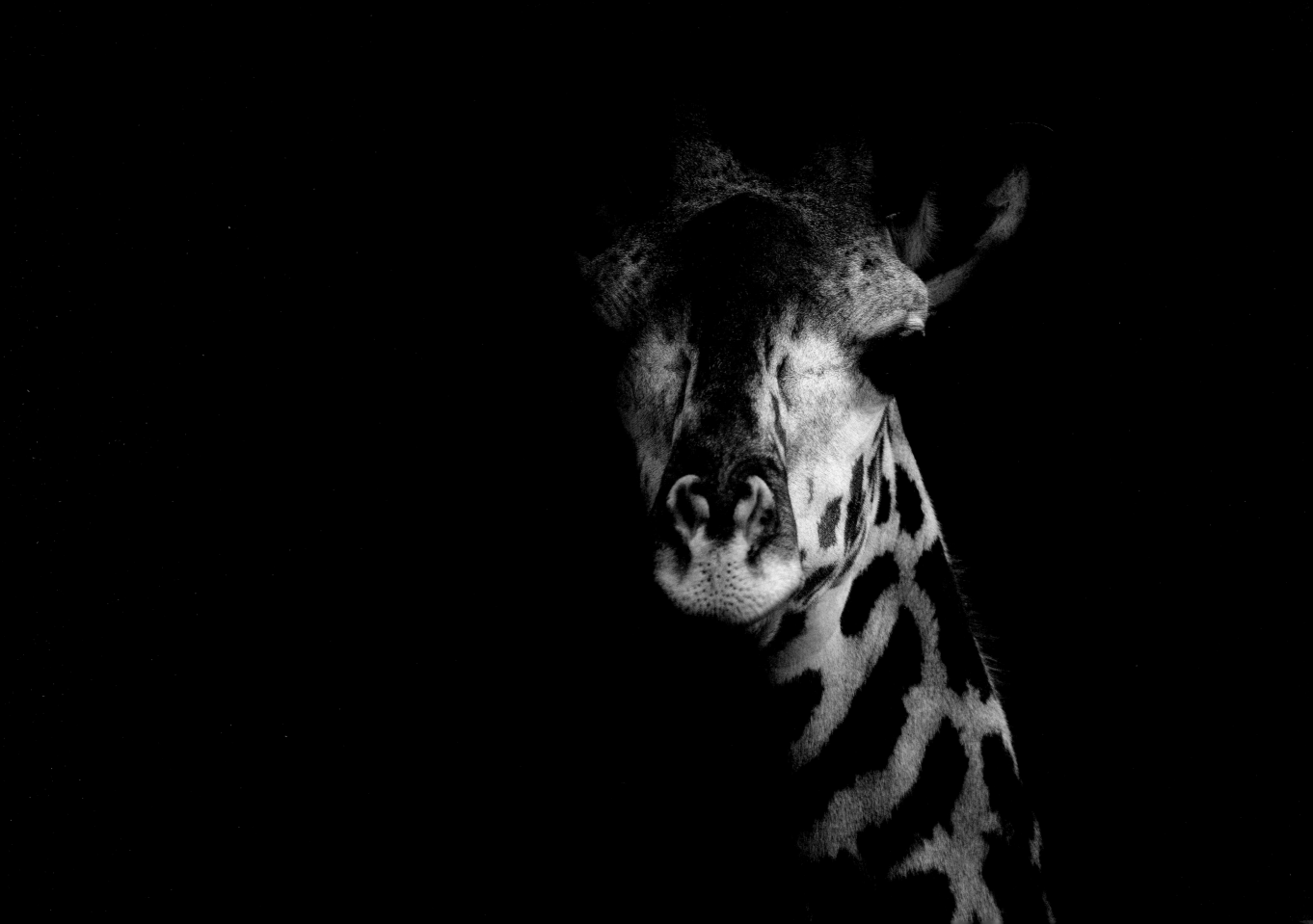

Some big cats are among the most threatened species.

The Amur Leopard probably numbers fewer than 50 individuals in the wild. Maybe as few as 25 to 35.

Iberian Lynx — wild population 100. Siberian tiger — wild population 500.

In 2004 a snow leopard had killed livestock worth between $600 and $1,300 in Hushey village in Pakistan. With an annual household income of $300-$400, the leopard was a significant economic threat to villagers' livelihood. The leopard was eventually captured, but released unharmed in recognition of its threatened status.

In 2007, the Russian government agreed to re-route part of a major oil pipeline in order to conserve the last remaining habitat of the Amur leopard.

PREVIOUS PAGES: Elegance
Pride

Anxiety

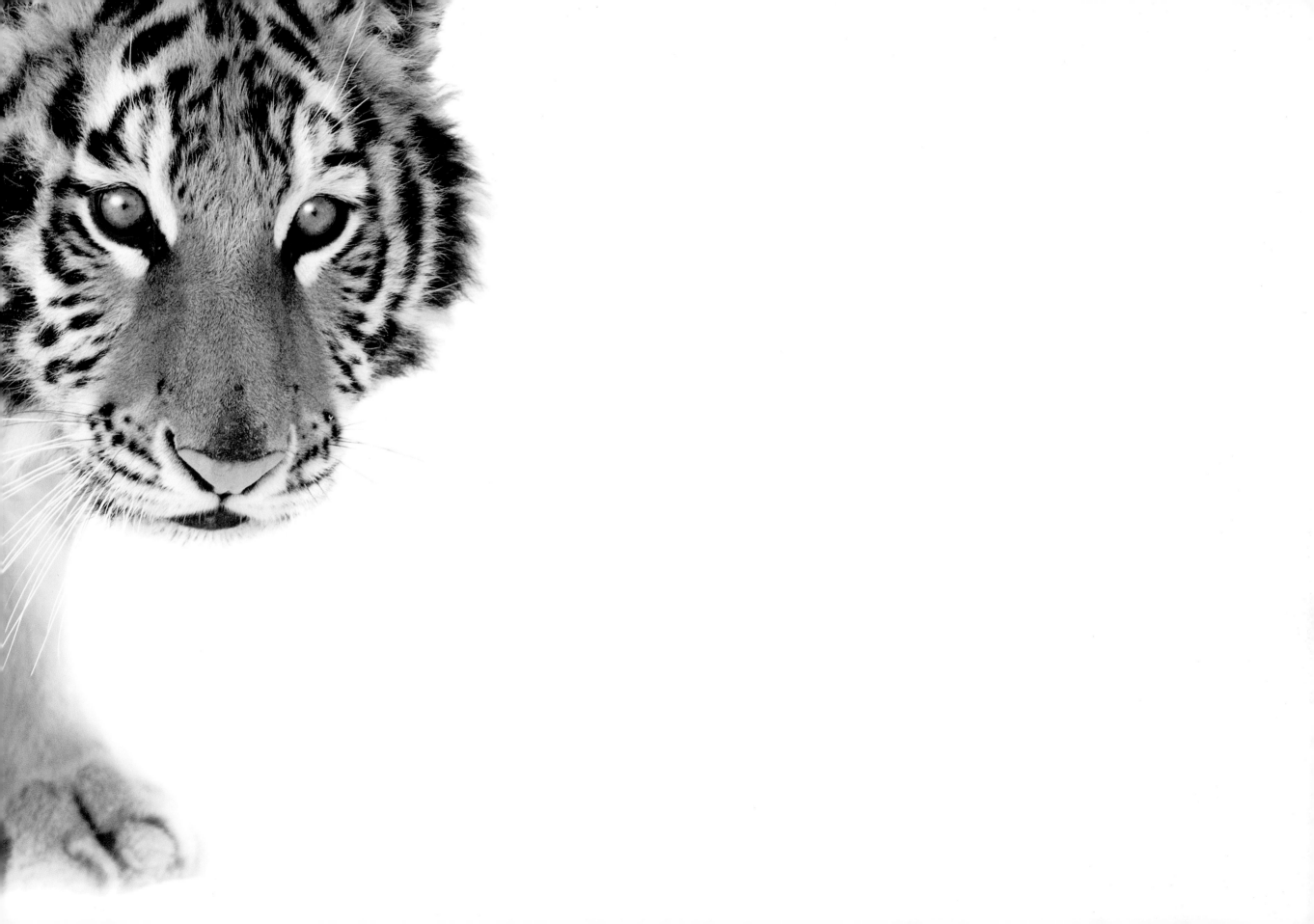

On December 27, 2006 the US Fish and Wildlife Service proposed listing the polar bear as a threatened species.

Climate change and global warming are causing rapid melting of the polar ice caps. The polar bear's habitat is literally melting away from under its feet.

The proposed classification of the polar bear as threatened due to loss of its habitat is the first time that the USA has officially accepted a direct link between global warming and species endangerment. Progress indeed!

At the time of writing, the USA and Australia remained the only two industrialized countries not to sign the Kyoto Protocol on climate change.

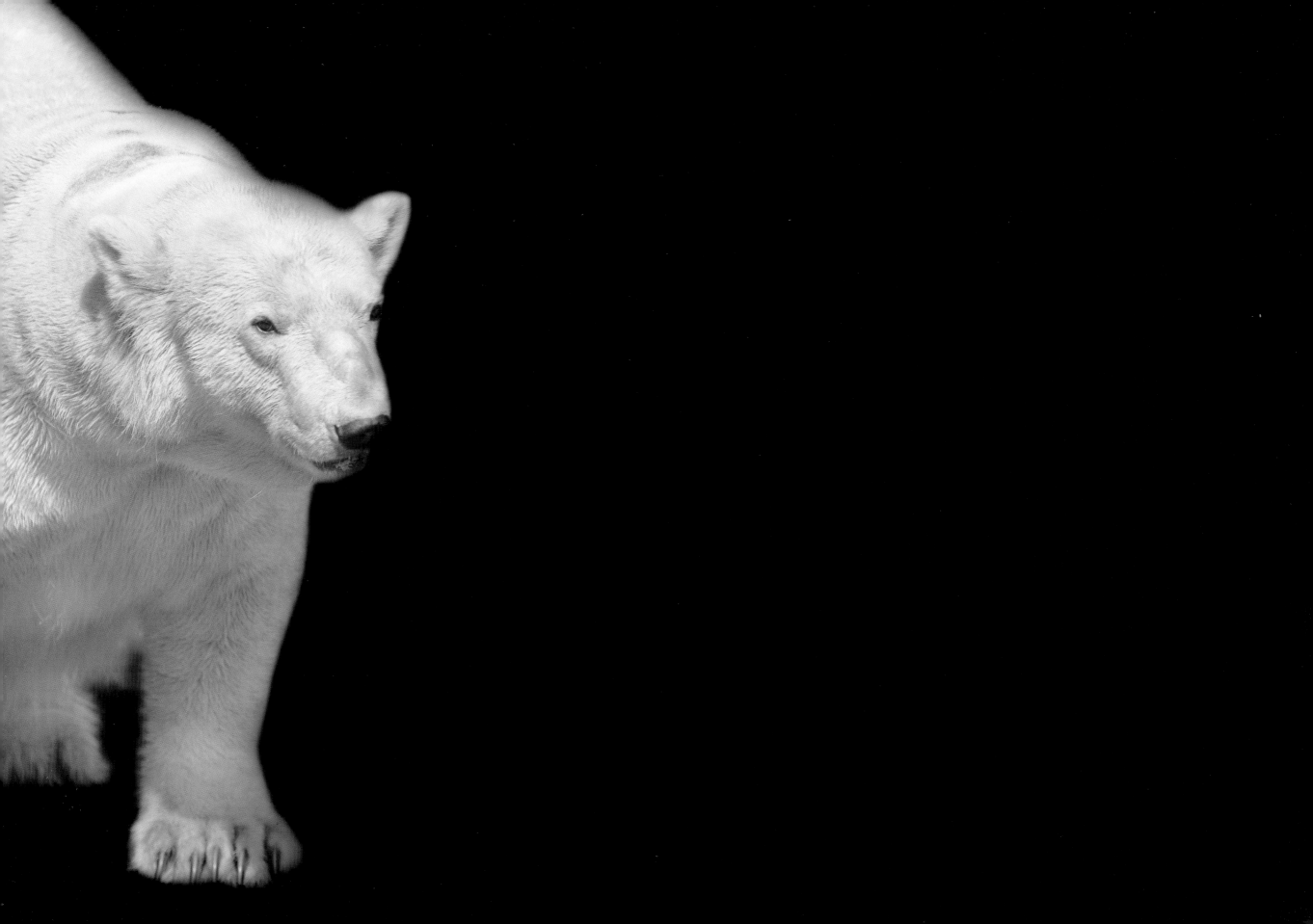

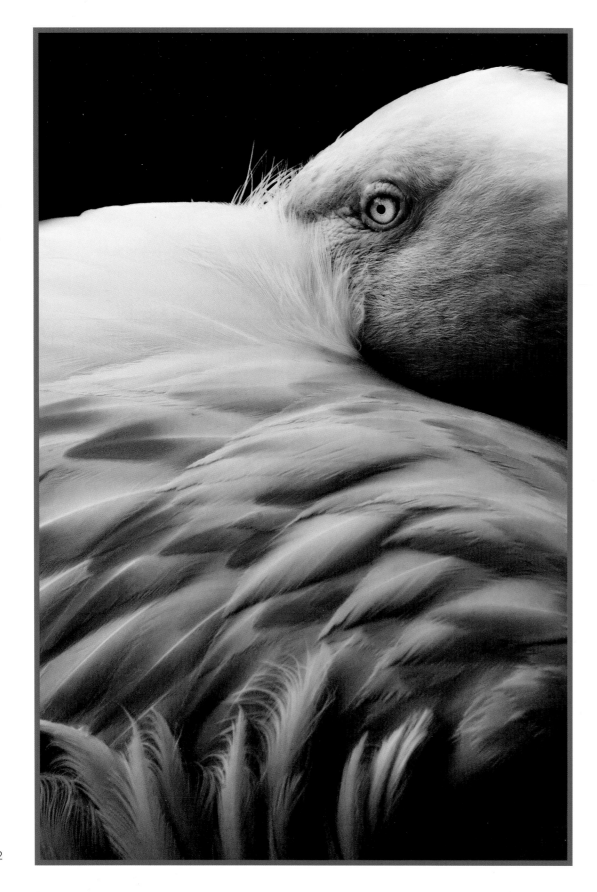

Feather Bed

The Bali Mynah: discovered 1910; virtually extinct in the wild by 2001.

It goes the way of the Bali Tiger — declared extinct in 1937

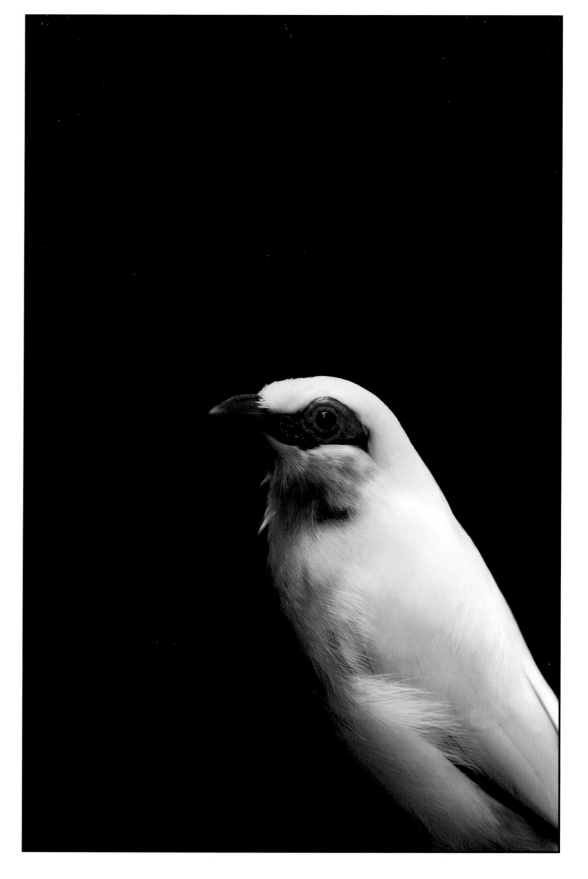

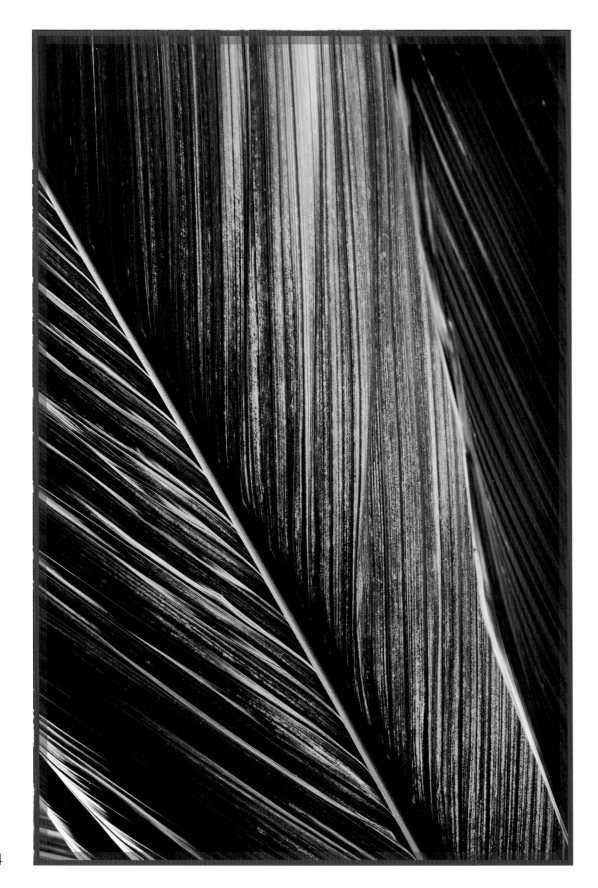

Although animal species — and large animal species in particular — get much of the attention, many plants are on the endangered species list.

Plants form the basic infrastructure of all habitats. They provide food and shelter and many other natural services. Conservation of plant species and habitats is a fundamental building block from which much else flows.

The beautiful fronds shown here are from a palm tree (*Pelagodoxa henryana*) found in a single valley in the mountains of the Marquesas Islands in the South Pacific. Land development for agriculture and human habitation has made this a critically endangered species. It is thought that less than twelve trees remain in the wild.

Plants are also responsible for most of the natural beauty that surrounds us. The Pride of Burma (*Amherstia nobilis* — opposite) is a mystical plant widely grown in the gardens of Buddhist temples and other places of meditation throughout the East. It is thought no longer to be growing in the wild.

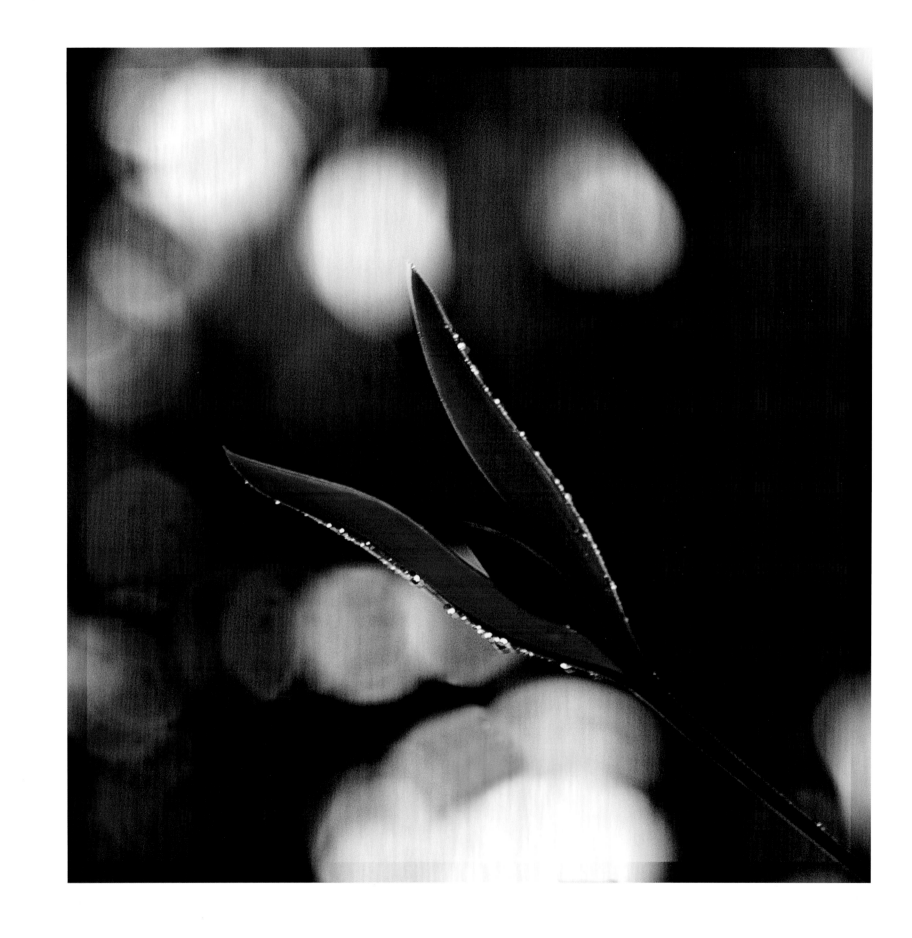

THIS PAGE: Lost Pride

OPPOSITE: Slashed

In keeping with Rastafarian tradition, Owen 'Bagga' Forrester (opposite) is a Jamaican herbal healer who has acquired international recognition for his work. Using herbal methods he helps countless locals irrespective of ability to pay. His many medical successes are well documented – often in circumstances where traditional medicine has failed.

We take so much for granted that it's easy to forget how ubiquitous is the use of plants in all aspects of our everyday lives. From cleaning products to perfumes and cosmetics; from our clothing to construction materials; from tonics and herbal medicines to modern pharmaceutical products; from our morning fruit juice to our evening scotch whiskey. And, of course, all our food is ultimately dependent on an infrastructure of plants.

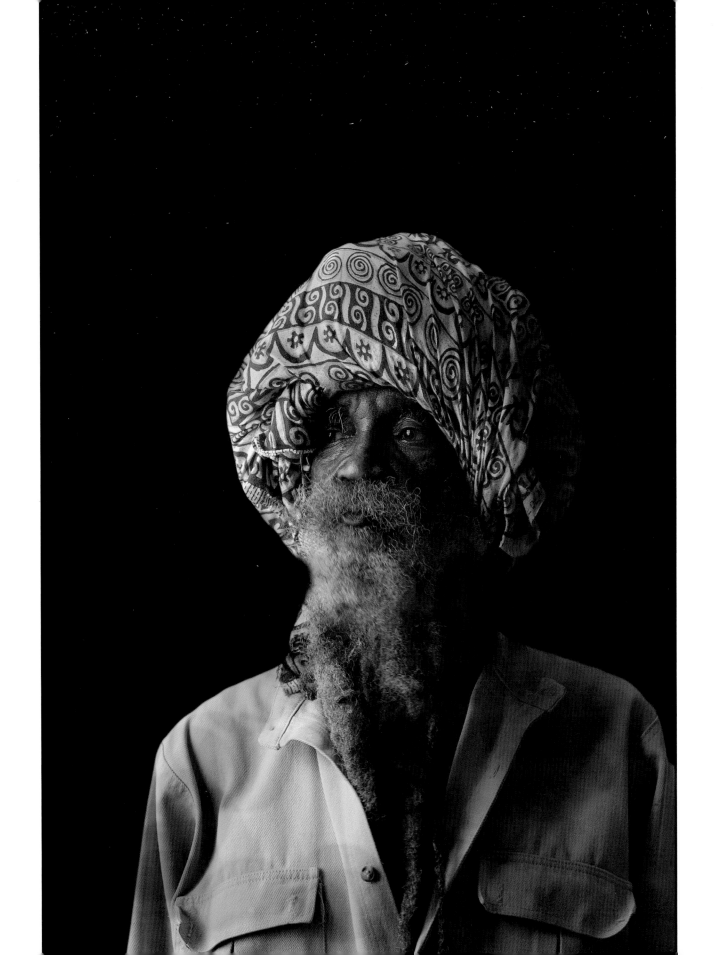

Medicine Man

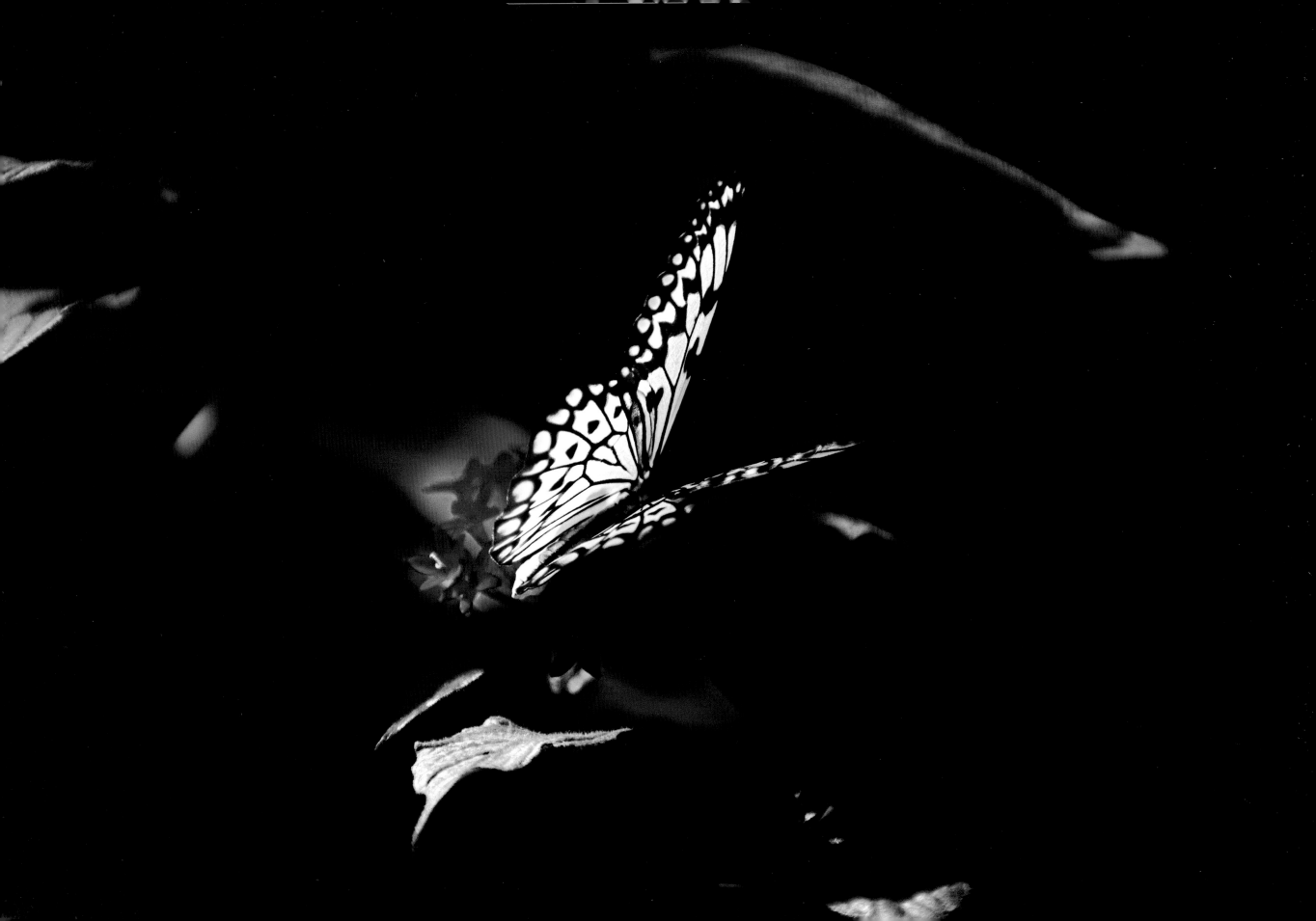

WHAT WE CAN DO

In practical terms, what can we, as individuals, do to help preserve the world's biodiversity. The tropical forests and other biodiversity hot spots seem so remote from our everyday lives that it's difficult to imagine that we can have any practical impact on the extinction of species.

There is much we can all do to help preserve threatened habitats and species.

Poaching and trade in endangered species continues across the world. Purchase of products derived from endangered species encourages this trade. Yet it is easy to fall into the trap of buying just that one little ivory carving, a piece of coral jewelry, an animal hide, a tortoise shell product or, as a treat, that one small can of sturgeon caviar — all items that could come from endangered species. We can be seduced by some exotic pet, not knowing that it is a poached, endangered species.

More commonly, we can and should avoid over-harvested species like Chilean sea bass, Atlantic cod, grouper, bluefin tuna and others (see page 46). We should stay away from restaurants that persist in serving these species.

We should not introduce exotic species of plants and animals into our habitats, however attractive they might seem. Exotic species can take over and destroy native plants and animals. The introduction of exotics accounts for 46 percent of US species endangerment.

We can make important contributions through our votes and charitable donations:

Support elected representatives and initiatives that preserve habitats and species. Withdraw our support from politicians and policies that encourage indiscriminate development and habitat destruction.

Encourage the use of government funds to help developing countries preserve their remaining wilderness places.

If we wish to make a direct financial contribution to the conservation of habitats and species, we should support appropriate environmental and conservation organizations. Choose well-managed organizations that can show that they have achieved practical results. Some organizations focus on scientific research or lobbying activities. Others mount practical, on-the-ground conservation programs (see page 110)

Finally, loss of species and habitats is inextricably linked to the overall deterioration of the global environment driven by our living habits and consumption patterns. We can make a difference through small yet highly effective changes to an environmentally conscious, modern lifestyle.

How we can move towards that goal is the subject of the next section.

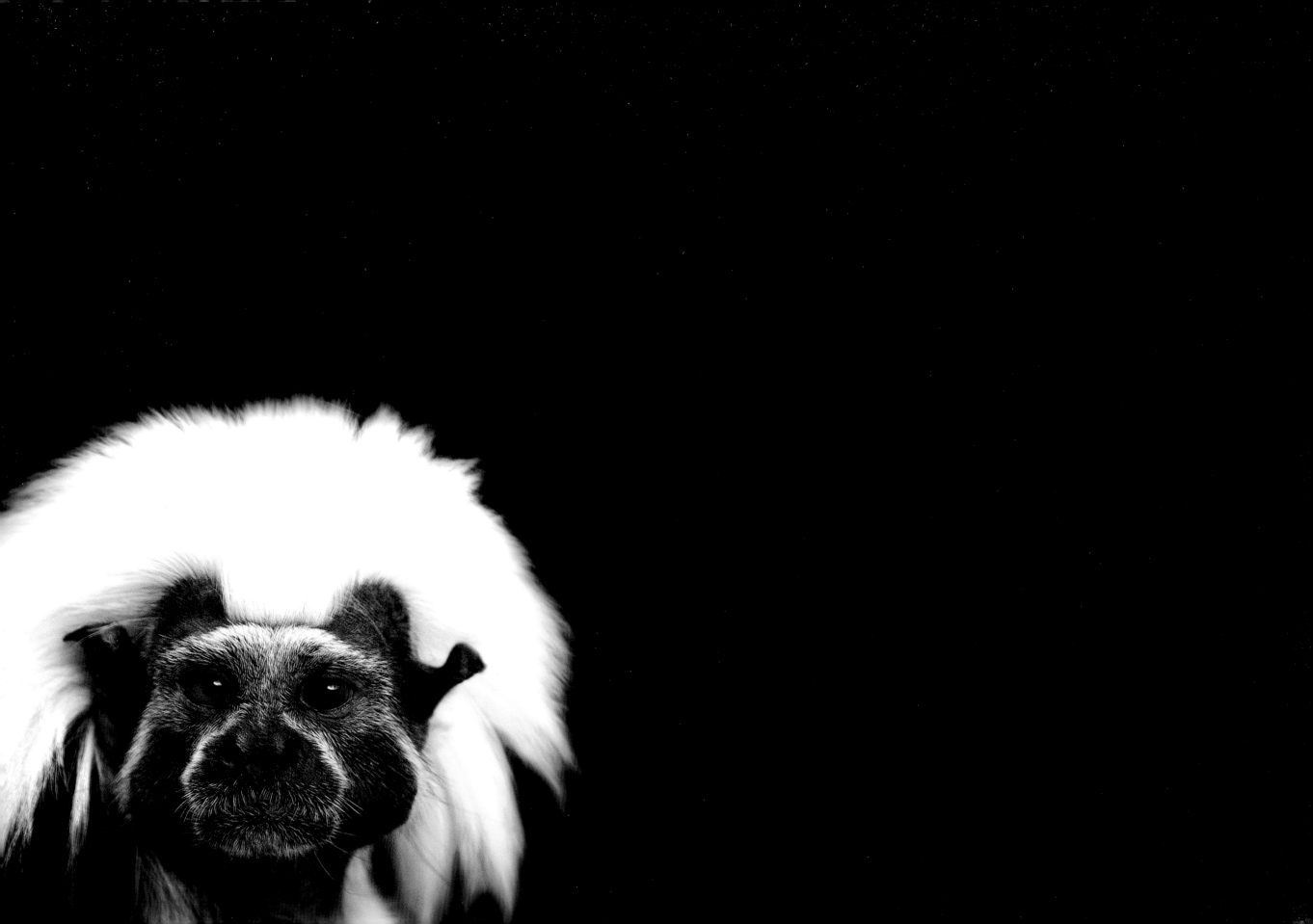

"No one who looks into a gorilla's eyes — intelligent, gentle, vulnerable — can remain unchanged, for the gap between ape and human vanishes; we know that the gorilla still lives within us. Do gorillas also recognize this ancient connection?"

—George B. Schaller,
"Gentle Gorillas, Turbulent Times," National Geographic, October 1995

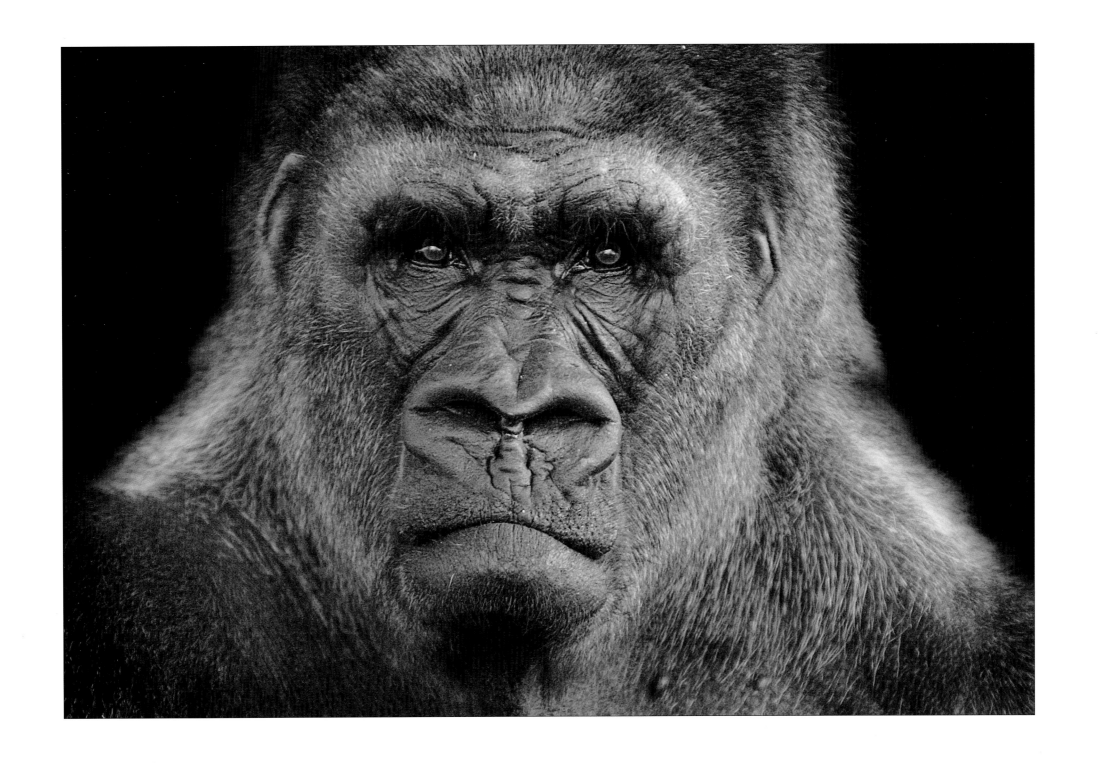

modern living

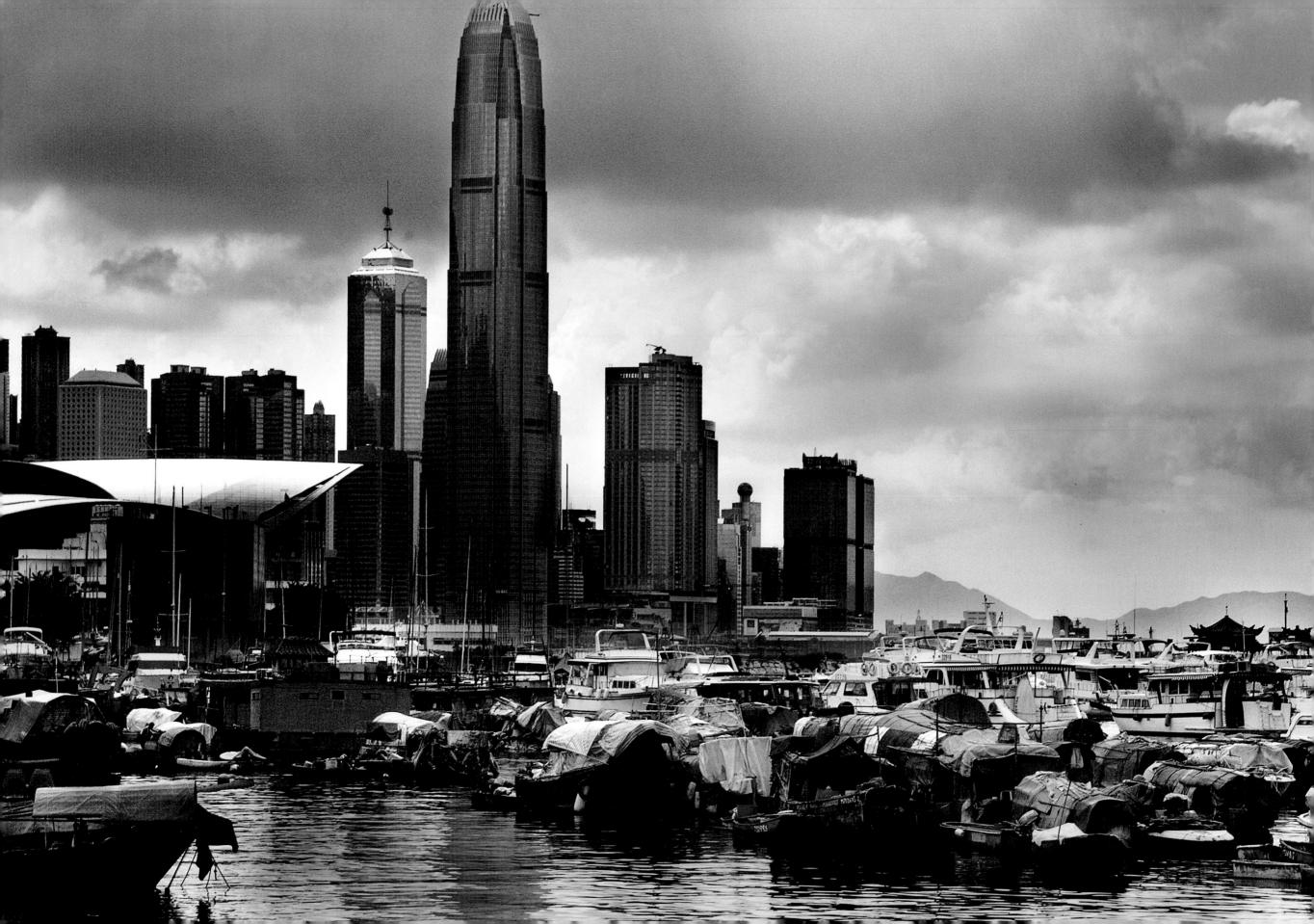

A strange thing is happening.

The way we define 'modern living' has changed dramatically. The fastest car, the biggest house and other symbols of consumption, emblems of modern living in the 1980s and 90s, have lost their shine. In the 21st century, the most advanced communities are defined differently. Recycling programs, use of alternative energy, well developed public transport infrastructure, ecologically sensitive building programs, organic farming, eco-friendly products; these are the characteristics we identify with the most advanced communities today.

Waste, over-use of energy and water, rapid, indiscriminate development, pollution — we now see these as markers of less developed communities that will become more environmentally friendly with improving local conditions, better education and access to modern technology.

An environmental consciousness and the ability to put that consciousness into practice has become one of the defining differences between the haves and the have-nots, the developed and the less developed, the educated and the less educated, the modern and the outdated.

Cities form one of the most vital elements in the continued health of our global environment.

More than half the population on Earth now lives in an urban setting. Over the next 25 years, 9 out of every 10 births will occur in cities. Cities hold a huge concentration of wealth, resources, educational establishments and the power to influence global thought. Much of our societal behavior originates in the city before spreading further.

Environmental conservation cannot be effective without the active commitment of city dwellers.

Cities are among the most environmentally friendly forms of human habitation — and they have the potential to become much more environmentally friendly in the future.

When organized effectively, the high population density in cities provides for a significantly lower environmental impact per head of population. Shared services, less wasteful dissipation of heat and energy, smaller travel distances making the use of public transport or low energy personal transport methods viable — these are some of the many ways in which cities lower their environmental impact.

Many city planners have learnt to maximize these benefits. Regeneration of inner city areas draws people back to previously derelict spaces. Encouraging cities to grow upwards rather than outwards minimizes the human footprint and its impact on the countryside.

Cities like Vancouver in British Columbia, Gröningen in The Netherlands, Portland in Oregon and others have come to epitomize modern living with low environmental impact.

THE EFFICIENCY OF HIGH DENSITY

If New York City were to become the 51st state of the US, it would be the twelfth largest state ranked by population. Yet, in terms of *per capita* energy use it would be number fifty-one. Manhattan uses less *per capita* resources and energy than anywhere else in America. And, lest there is some doubt, it's not because Manhattanites are naturally ascetic and low consumers. It is simply a function of the efficiency of high density.

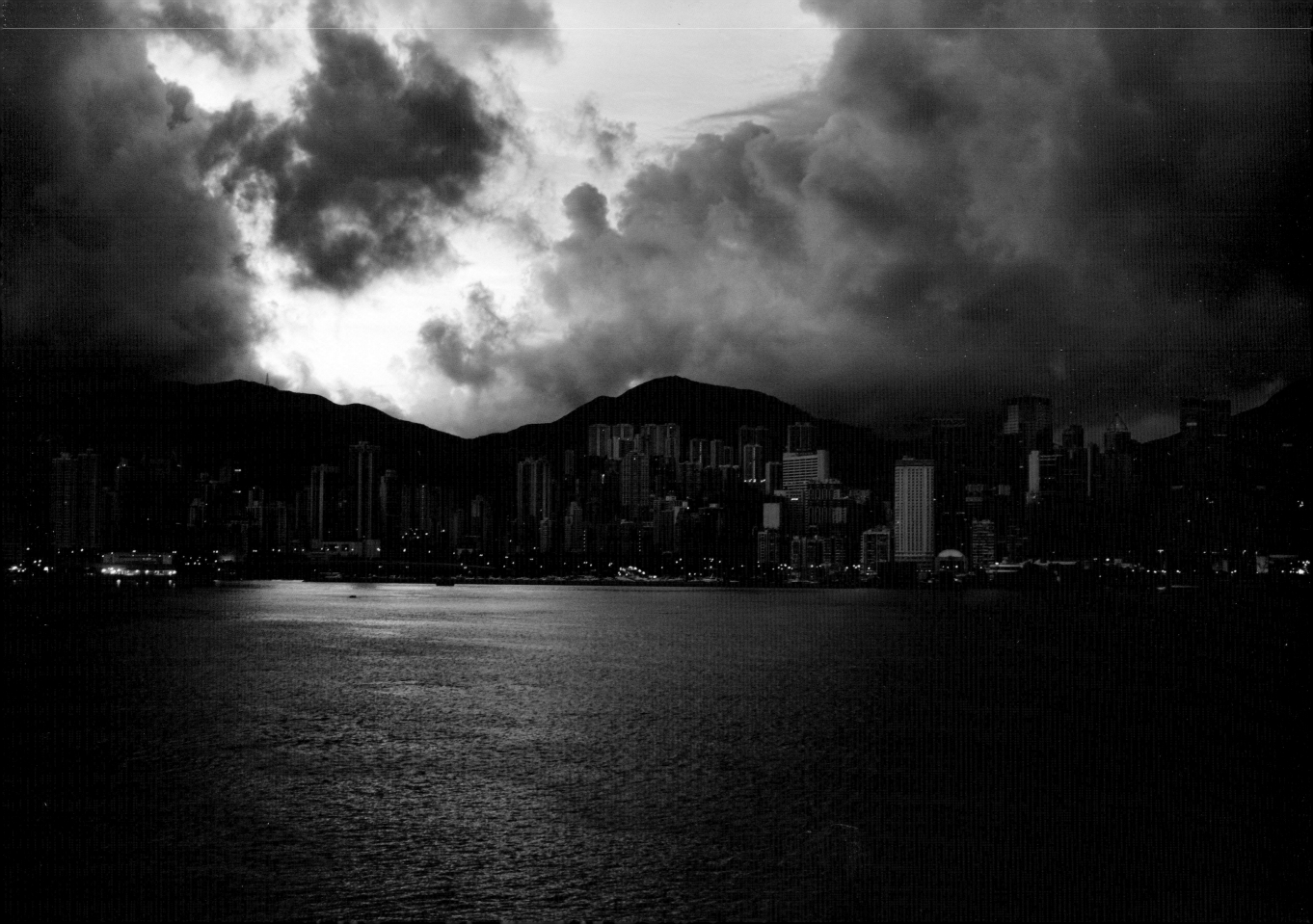

There was a time when people naturally lined city streets with trees, built parks and softened the neighborhood making it more livable. Today, the tyranny of budgets and simplistic economic analyses call into question the value of what once seemed obvious.

Trees in towns and cities provide services that go beyond people's aesthetic wellbeing. Providing shade and wind protection, they reduce energy consumption and weather damage to housing. They can protect against flood, landslide, land erosion and other damage. By absorbing carbon dioxide and other pollutants, trees create a cleaner local climate. Finally, houses in tree-lined areas and near parks have a consistently higher market value.

New York City has calculated that, overall, the city receives $5.60 in benefits for every $1 spent on trees. A total net annual benefit to the city of $122 million.

It has also been shown that green spaces in cities promote community togetherness, reduce crime and improve health.

And people do enjoy their parks — should anyone care about that.

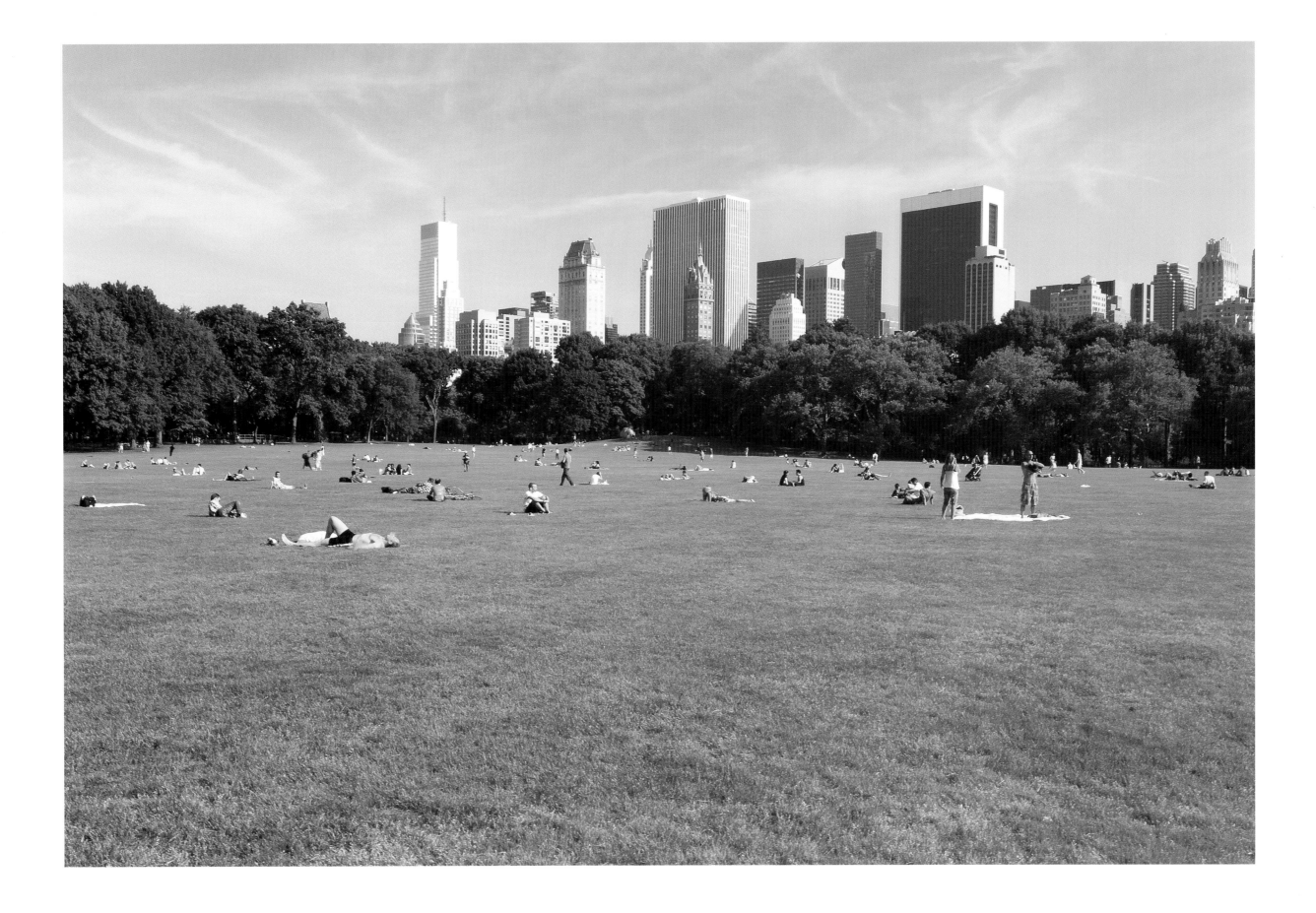

In his wonderful book about his return to live in the USA, Bill Bryson amuses the reader by describing how he and his wife got into their car to drive to their next-door neighbor's house for dinner. ·

The motor car, one of the most liberating developments of the 20th century, has become one of the main sources of emissions on the planet while imbuing us all with an embedded laziness that makes us jump into our vehicle for the shortest of journeys.

Innovation in personal and public transport is starting to show the benefits to be had. Here again, the compact nature of cities and their self-contained neighborhoods show their strength. Building an effective public transport infrastructure and using alternative, energy-saving forms of personal transport are more achievable in a city environment than in the sprawling suburb where buying a pint of milk inevitably involves a two-mile drive. In some cities and neighborhoods we can even simply walk around — imagine that.

While badly managed cities wring their hands about the difficulties of installing an effective transport system, others are getting on with showing the way forward.

Curitiba in Brazil has built and kept up-to-date a public transport system that has inspired successful imitations from Quito in Equador and Bogota in Columbia to Ottawa, Brisbane and Jakarta.

Others have been creative in other ways, encouraging the use of mopeds or bicycles to replace car journeys by making it safer, easier and cheaper to use these methods of transport. In Gröningen, in The Netherlands the city has persuaded people to use bicycles for 60% of their journeys. In Denmark, two-fifths of people in Copenhagen bicycle to work — in spite of the weather. The city of Barcelona supports 'Bicing", a company that provides locked bicycle stations around the city. For €6 a year, people can release a bicycle ride it round the city and leave it at the next bicycle station for the next person to use.

Bangkok has reduced air pollution by 20-50% through various measures including making all taxis run on subsidized liquid natural gas.

Public Transport

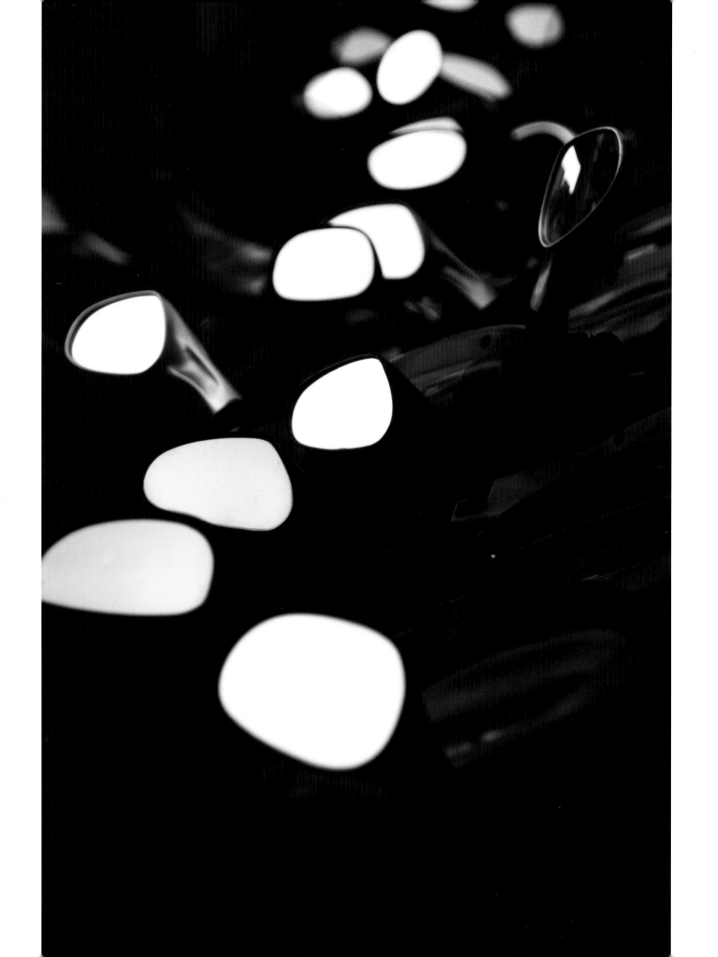

THIS PAGE: Mopeds
FACING PAGE: Bicycles

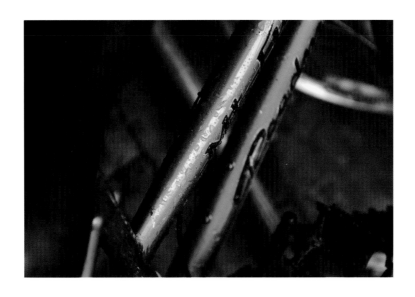
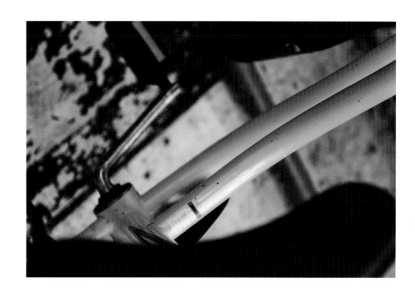

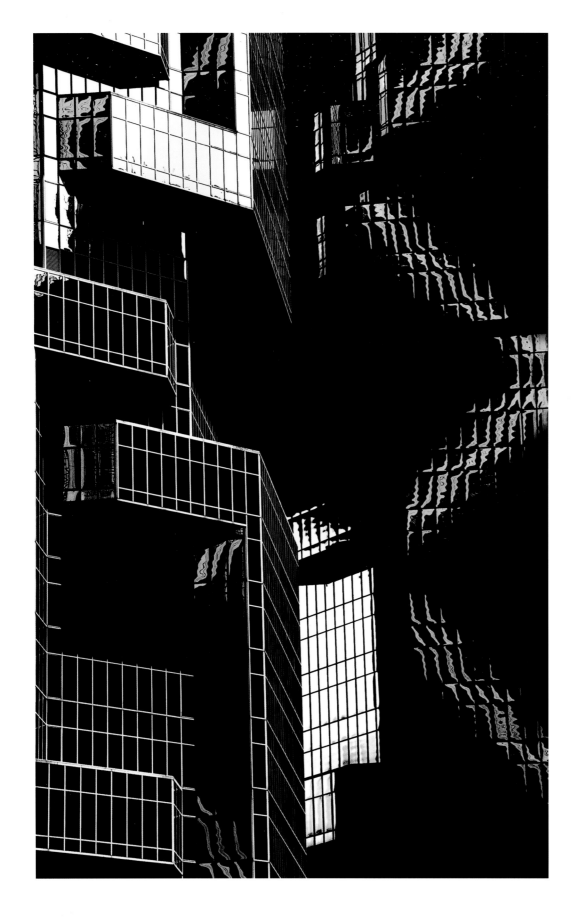

In the past. public and corporate buildings were designed purely with an eye to getting the maximum short-term economic return from the available budget or simply for the aggrandizement of the local community, the nation or the corporation.

Today environmental considerations and the promotion of a sense of wellbeing form a major part of building design. All international architectural competitions now have stringent environmental design requirements and a green streak runs through most modern developments.

The newly re-designed Reichstag in Berlin uses an efficient, sustainable energy strategy while making the maximum use of natural light to convey a feeling of openness and transparency. The Swiss Re Headquarters in London (affectionately known as the Gherkin) uses open space and ventilation to combine energy efficiency with open working spaces. Other designs offer greenery where you least expect it. Trees inside and outside buildings blur the boundaries between indoors and outdoors. Rainwater capture and wastewater recycling are starting to make their way into many modern building complexes.

Standards for green building design are being established through programs such as the Leadership in Energy and Environmental Design (LEED) standards established by the United States Green Building Council.

Domestic building design has, so far, lagged behind the strides being made in commercial and public buildings. But even here progress is noticeable. Smaller, more compact housing is more efficient than sprawling, low-rise mansions. Energy-efficient houses with improved design basics can significantly reduce energy waste. New technologies like geo-thermal heat exchangers, solar panels and others are making their way into new developments.

One remaining issue is the up-front investment needed to incorporate these new technologies into domestic housing. Maybe a new environmental financing market will emerge even as costs continue to fall.

THIS PAGE: Modern
FACING PAGE: Green Streak

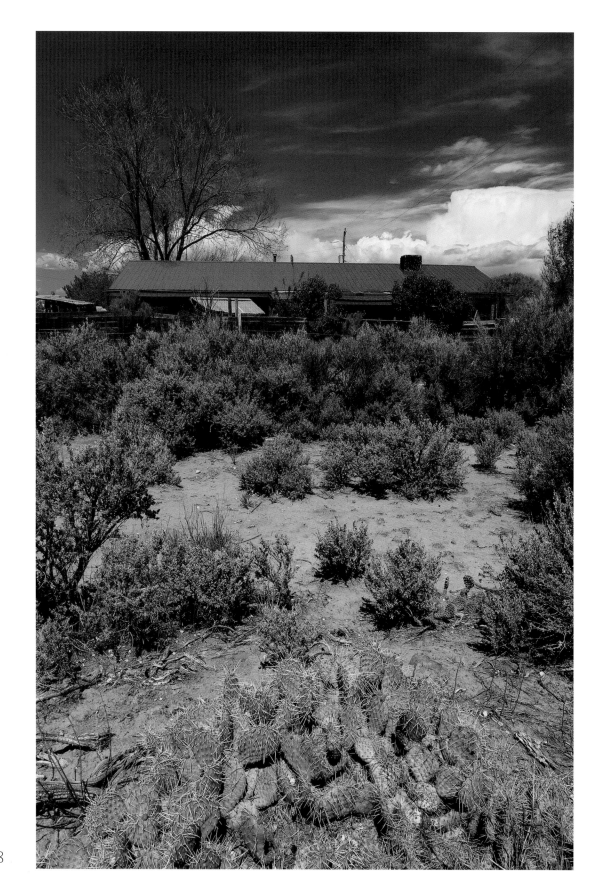

Suburbs are far less environmentally friendly than cities. Building in natural areas destroys ecosystems. Even the most minimal development of a few houses has a significant negative impact.

Around 35 percent of land-based endangered species are threatened by the expansion of residential housing and all the associated development in terms of roads and other amenities.

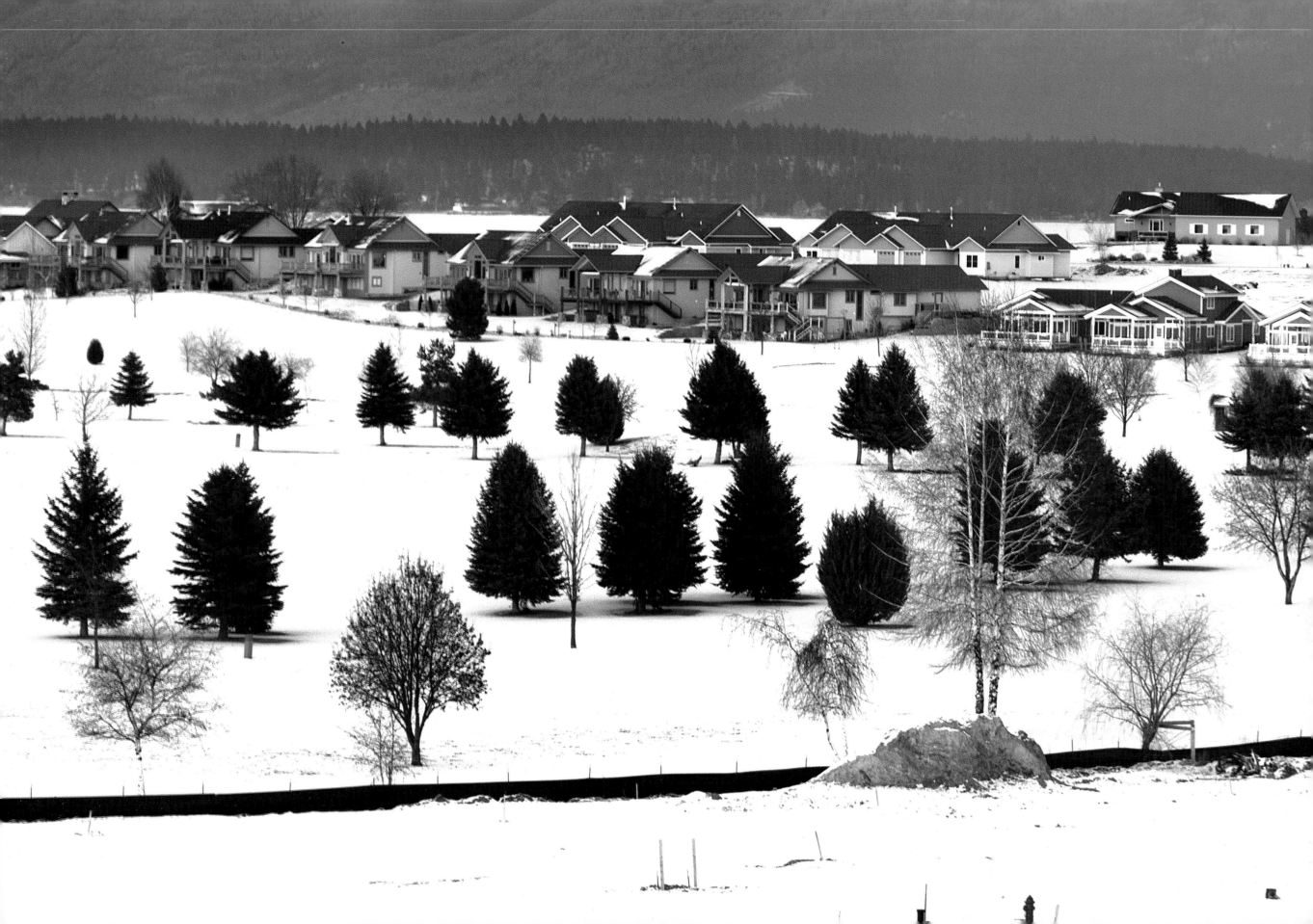

In a world where misunderstandings between groups, nations and peoples lead to continued conflict, ease of transport and travel has a vital role to play in providing personal freedom, enhancing trade and promoting cultural exchange and mutual understanding.

This need to bring the world closer together must be balanced against the substantial impact of transport and travel on greenhouse gas emissions and climate change. These conflicting priorities were reflected in a landmark debate at the United Nations Security Council in 2007. While the Council remained acutely aware of the security issues raised by continued misunderstandings between cultures and nations, the United Kingdom, a permanent member of the Council, proposed that climate change should be considered a significant future threat to global security.

In balancing these conflicting priorities, successful policy initiatives focus on encouraging increased efficiency in transport and travel through new technology and programs such as carbon trading schemes rather than attempting to discourage the free movement of goods and people through taxation and tariffs.

At a more personal level, organizations like TerraPass (www.terrapass.com) allow us to offset our carbon emissions by purchasing carbon offset credits whenever we travel. The funds raised are put towards generating alternative, sustainable forms of energy.

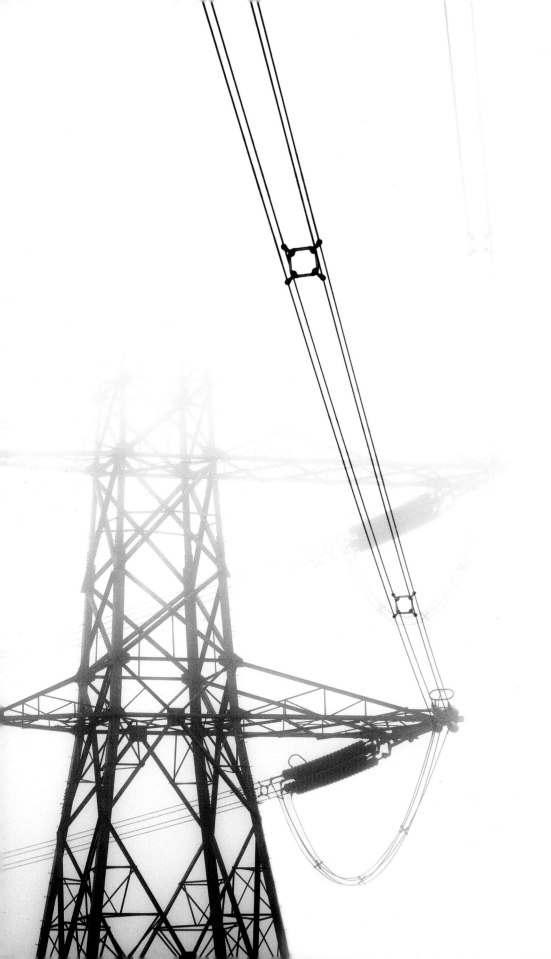

Energy generation remains the biggest contributor to greenhouse gas emissions.

The past several years have seen a notable increase in policy initiatives, incentives and legislation to encourage industry and individuals to become more energy efficient and to use alternative sources of energy.

Maybe nowhere more than in the area of power generation and use does scientific innovation offer so much hope for the future. Bio-fuels, wind, solar power, fuel cells, carbon capture, fusion, and others. These are some of the technologies that offer the promise of a future where our ever-increasing demands are met through a balanced mix of energy sources much less environmentally damaging than our current reliance on fossil fuels.

THIS PAGE: Power
FACING: Coal

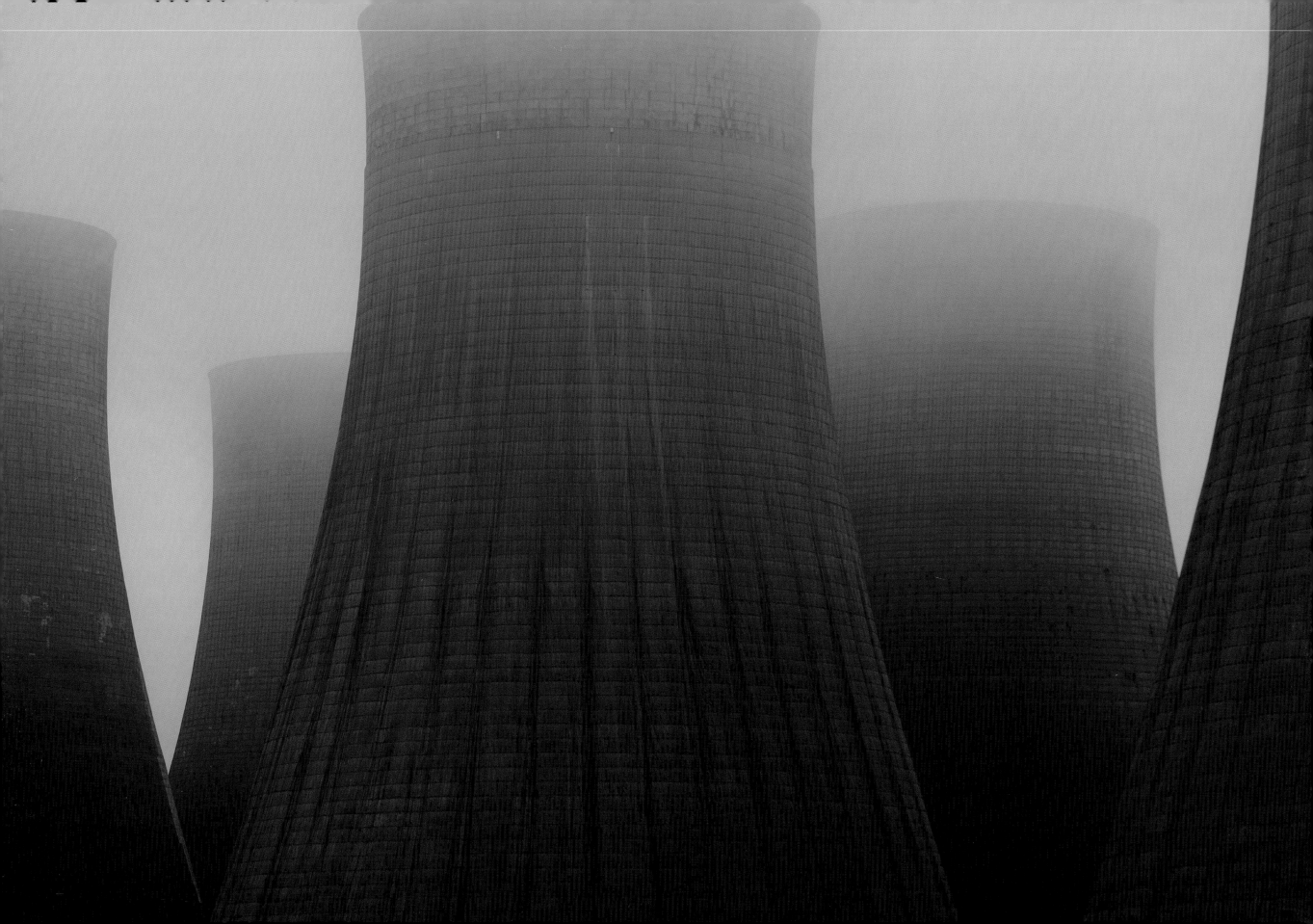

In the UK, it has been calculated that if all households replaced just one single incandescent light bulb with an energy efficient compact fluorescent light (CFL), the money saved would pay the fuel bills of about 75,000 families.

The numbers are staggering. They show how small actions that we can all take in our daily lives have the potential to add up to a huge impact on all aspects of environmental conservation.

When we choose certified organic food or use biodegradable products, we reduce the use of pesticides and other chemicals that damage our water and flow into the land and the oceans, damaging plant and animal species and, in turn, pollute our own food sources.

Effective re-cycling programs are growing in the more advanced communities. But even in the absence of such programs, we can change bad habits that have become an integral part of our daily lives. Reducing our use of plastic disposables; choosing re-usable rather than disposable bags for our shopping; using modern, water-saving showerheads and faucets; microwave ovens instead of convection ovens; when we have a choice, buying our energy from a supplier offering sustainable energy sources; as employers and employees, using technology to encourage tele-commuting rather than daily, long journeys to work. These and several other small actions cause us little or no inconvenience, often save us money and, multiplied millions of times over across the world, will have a dramatic positive impact on our environment.

*"Everyone thinks of changing the world.
But no one thinks of changing himself"*

—Leo Tolstoy

THIS PAGE: Bio-degradable
FACING: Non-disposable

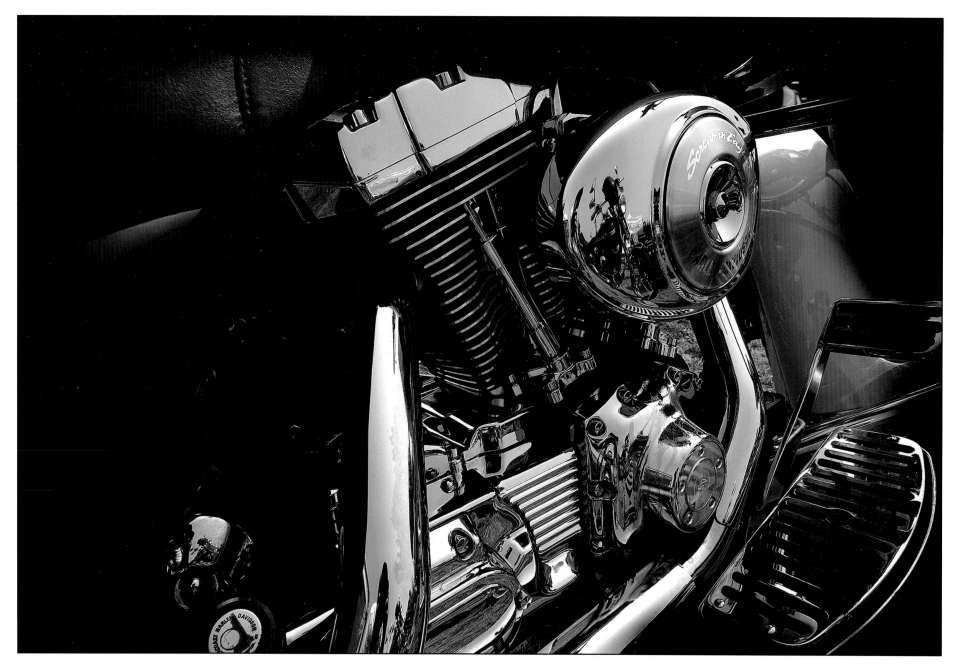

Maybe nowhere more than in our choice of personal transport can we have so much direct impact on climate change and environmental degradation. In the past, muscular machines were part of everyone's road dream. Today, encouraged by government incentives, high fuel prices and personal preference, vehicles from hybrid cars to Smart cars populate our roads while new regulation continues to limit allowable emissions from all vehicles.

THIS PAGE: Past Dreams
FACING: Smart

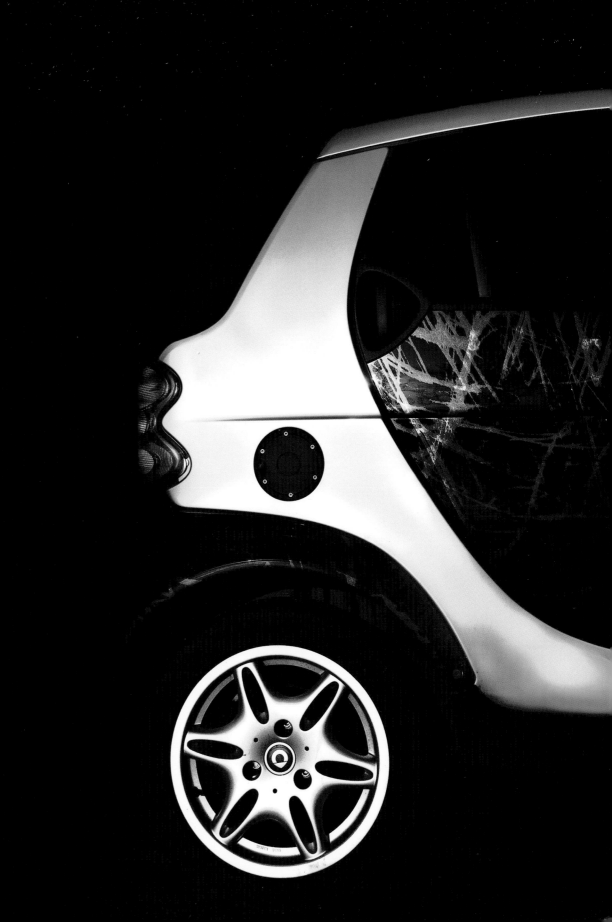

THIS PAGE: Grain
FACING: Meat

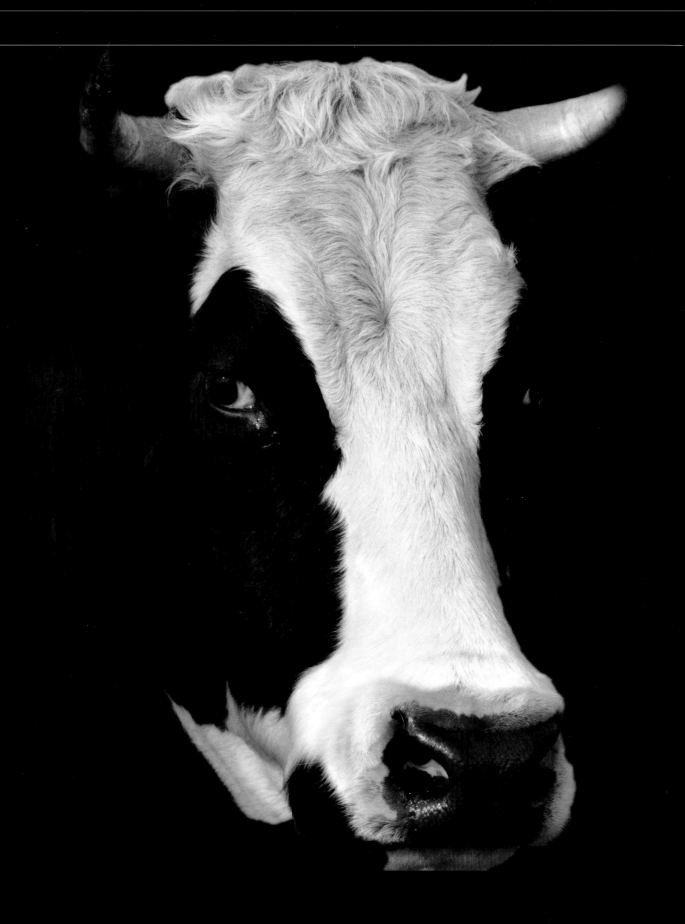

Meat or vegetables?

The same amount of grain that would feed approximately one billion people eating a largely vegetarian diet would only feed 250 million people on a typical American diet, where most of that grain is converted to meat and poultry.

The environmental impact of a western style diet, heavier on meat than is necessary (or even good) for our health is substantial. Land use is increased substantially leading to more rapid land clearing and deforestation. Beef and pork have higher land use per pound of production compared to poultry.

While asking everyone to convert to a vegetarian diet is neither viable nor desirable, reducing individual meat consumption, even modestly, shifting much of the meat we consume from red meat to poultry while increasing our consumption of dairy products and organic fruit and vegetables will have a positive impact on the environment and on our own health.

The apocryphal story goes that when Christopher Columbus returned from the New World to announce that the world was not flat but round, everyone nodded politely while holding on to their long held belief that the world was, in fact, flat. Then those people died and new generations sprang up, each one more convinced that the last that the world was round.

So it may be with the conservation of our environment. While today we are more convinced than our parents' generation that our environment is precious and needs protecting, many of us may be too set in our ways to make substantial changes to our beliefs and life-styles. Governments may be too weak, too corrupt or too entwined with vested interests to make the necessary policy changes. But new generations offer hope.

Our legacy to our children is a world damaged through decades and centuries of self-centered, excessive human consumption. It is already too late to give them back what we have destroyed. However, through upbringing and education we can at least give the new generation something precious; an understanding of the value of the natural world around them, habits that are less profligate than our own and an environmental conscience that makes them able and willing to care for their planet and its inhabitants better than we have been able to care for it on their behalf.

The future may truly be bright.

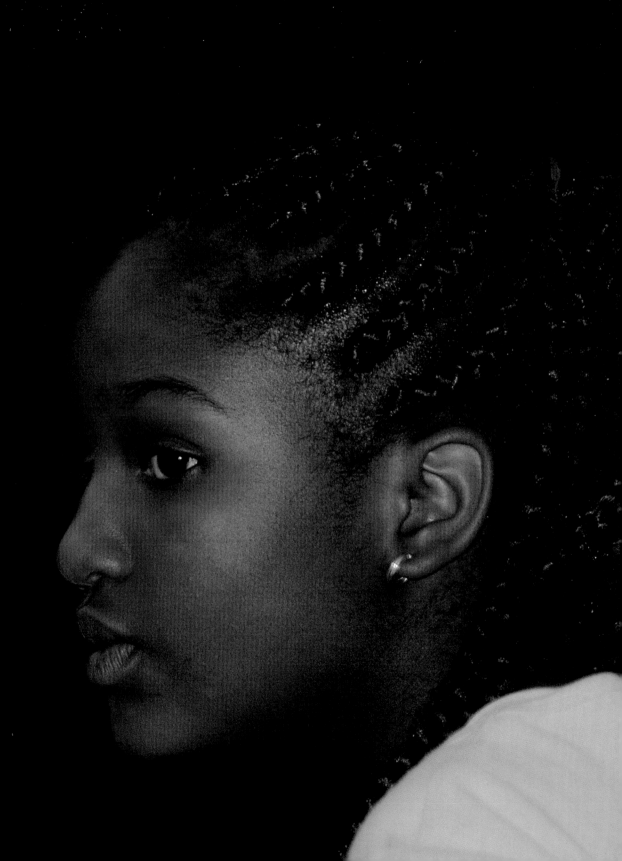

"Children should always show great forbearance towards grown up people"

—The Little Prince
Antoine De Saint-Exupéry

afterword

taking the world stage

When I was invited to review *First Steps* as a photography exhibit in New York, what struck me above all was that Joe Zammit-Lucia is clearly gifted with a thorough knowledge of social and cultural history and the craft of capturing imagery through his camera. He is an artist with a mastery of the art of knowing how and what to present to the public eye. With interest I have followed his application of these skills to take the work to the now complete next stage — expansion and enlargement into book form. Made more widely accessible, the material can continue to make what is doubtless a significant contribution to world thought.

I am sure that, like me, you have found that this book has the power to draw you in and generate a desire to become involved with the issues. This is skillfully done through the combination of words and images.

The text, with its tone of gentle concern and even-handed persuasion, has been deftly connected with its corresponding imagery to bring out the subject and content of Zammit-Lucia's efforts. The photography is identifiable by the use of dramatic cropping, surprising and unexpected flashes of brilliant color and brilliant tonal studies of silvery grays, blacks and sepia tones. The images are so distinctive they immediately create deep-seated emotional and intellectual connections with the viewer.

The author has taken pains to bring to light nascent, eco-friendly initiatives that are helping to invigorate the environment. Imagery relating to the natural world, Mother Nature's dominion in the form of her forests, oceans, and nearly extinct mammals, holds a special place in this collection. Here Zammit-Lucia's imagery is singularly impressive in its stark and sleek beauty.

Through this public address project, the artist is clearly involved in pointing to the fragile state of resources, their consumption, augmentation, distribution, and potential depletion. In so doing he has suggested to us that, as we look at the environment as capital, we see that too often it has been short-sightedly squandered rather than judiciously husbanded — let alone equitably maintained for future generations.

The artist comes across as an active, discerning observer of the world in the midst of very widening and deepening environmental change. His keenly composed and often unpredictable imagery allows the viewer to take in the textual commentary; keeping a global picture in mind while indicating how interests in various parts of the world, while seemingly having independent agendas, are linked in a vast chain of cause and often inadvertent effects. Such paeans to interdependency are not new, yet the way Zammit-Lucia interjects his understated cautionary inferences without undercutting his essentially hopeful world-view for the future is what remains so fascinating to me.

When I first saw the *First Steps* exhibit, I described it as "a visual policy paper". How much more involved in important issues of public policy could we all become if they were made to come alive with the gracefulness and lucidity seen in this work. Joe Zammit-Lucia has given us what every good artwork usually proffers to the viewer: a compelling and individuated story told with economy of means. Just as good art is efficient in the sense that it is thought embodied in form, so too bad art is thought outside of form

In *First Steps* a happy marriage between words and images leads to a full and unique aesthetic experience. Joe Zammit-Lucia's warm documentary style exerts its pull on the viewer's mind precisely because *First Steps*, in eschewing an *agit-prop* stance towards the viewer, offers in its stead a tone of gentle persuasiveness and of ineffable reverie. Here, the sensual and the cerebral, the passionate and the dispassionate co-exist in equal measure and have been deployed in the service of mutual understanding and world harmony.

—Dominque Nahas
Curator and art critic
New York, New York

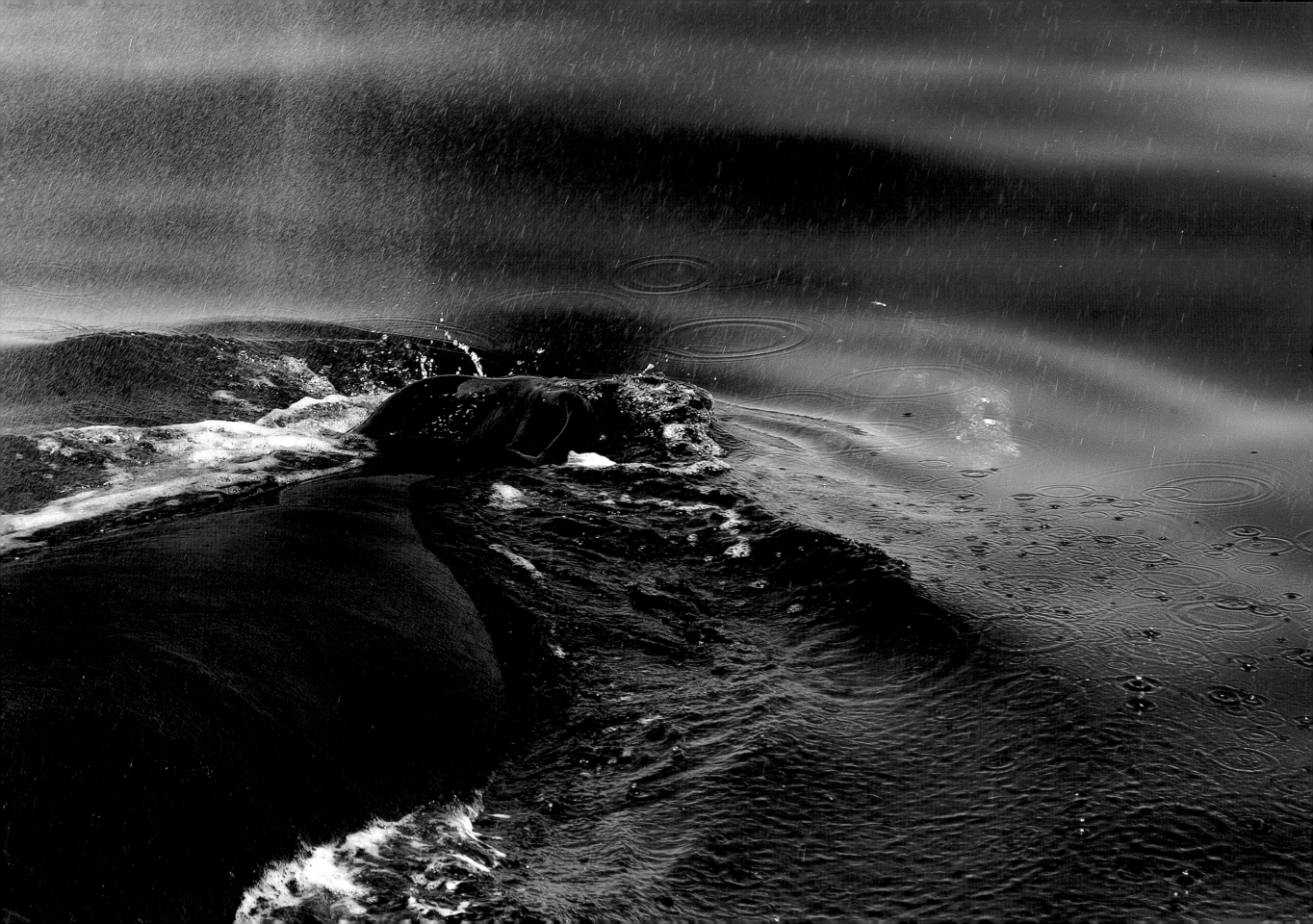

resources

environmentally conscious living

Get a better car	www.fueleconomy.org
	www.greenercars.com
Center for a New American Dream	www.newdream.org
Center for Renewable Energy And Sustainable Technology	www.crest.org
Children's Environmental Health Network	www.cehn.org
Earthshare	www.earthshare.org
Forest Stewardship Council	www.fscus.org
Green Living	www.biggreenswitch.co.uk
Gardens Alive!	www.gardensalive.com
Is your dry cleaner green?	www.greenearthcleaning.com
Healthy Eating	www.revolutionhealth.com/healthy-living/ food-nutrition/alternative-food-attitudes/
Marine Conservation Society	www.mcsuk.org

The Next American City	http://americancity.org
Organic Consumers Association	www.organicconsumers.org
Seafood Choices Alliance	www.seafoodchoices.com
Offset your own emissions	www.terrapass.com
Union of Concerned Scientists	www.ucsusa.org
US Environment Protection Agency	www.epa.gov
US Green Building Council	www.usgbc.com

environmental news and opinion

BBC — The Green Room	http://news.bbc.co.uk/1/hi/in_depth/ sci_tech/green_room/default.stm
Earth Info	www.earth-info.net
EcoNet	www.igc.apc.org/igc/econet
Environmental News Network	www.enn.com

environmental organizations

Center for Tropical Plant Conservation www.fairchildgarden.org
at Fairchild Tropical Botanic Garden

The Conservation Fund www.conservationfund.org

Conservation International www.conservation.org

Earth Council Alliance www.earthcouncilalliance.org

Environment Liaison Center www.elci.org
International

European Environment Agency www.eea.europa.eu

Forest Trends www.forest-trends.org

Friends of the Earth www.foei.org

Greenpeace www.greenpeace.org

Institute for Global Environmental www.iges.or.jp
Strategies

International Federation of Organic www.ifoam.org
Agriculture Movements

IUCN — The World Conservation Union www.iucn.org

The Nature Conservancy www.nature.org

The Ocean Conservancy www.oceanconservancy.org

Rainforest Action Network www.ran.org

United Nations Environment Programme www.unep.org

WWF - Wildlife Fund for Nature www.panda.org

Wildlife Trust www.wildlifetrust.org

World Association of Zoos www.waza.org
and Aquariums

For a comprehensive list of environmental organizations world-wide, visit:

IUCN Member Directory Database
http://intranet.iucn.org/kb/pub/members/directory.cfm

Wikipedia:
http://en.wikipedia.org/wiki/List_of_environmental_organizations

World Environmental Organization Top 1000 web sites:
http://www.world.org/weo/top1000

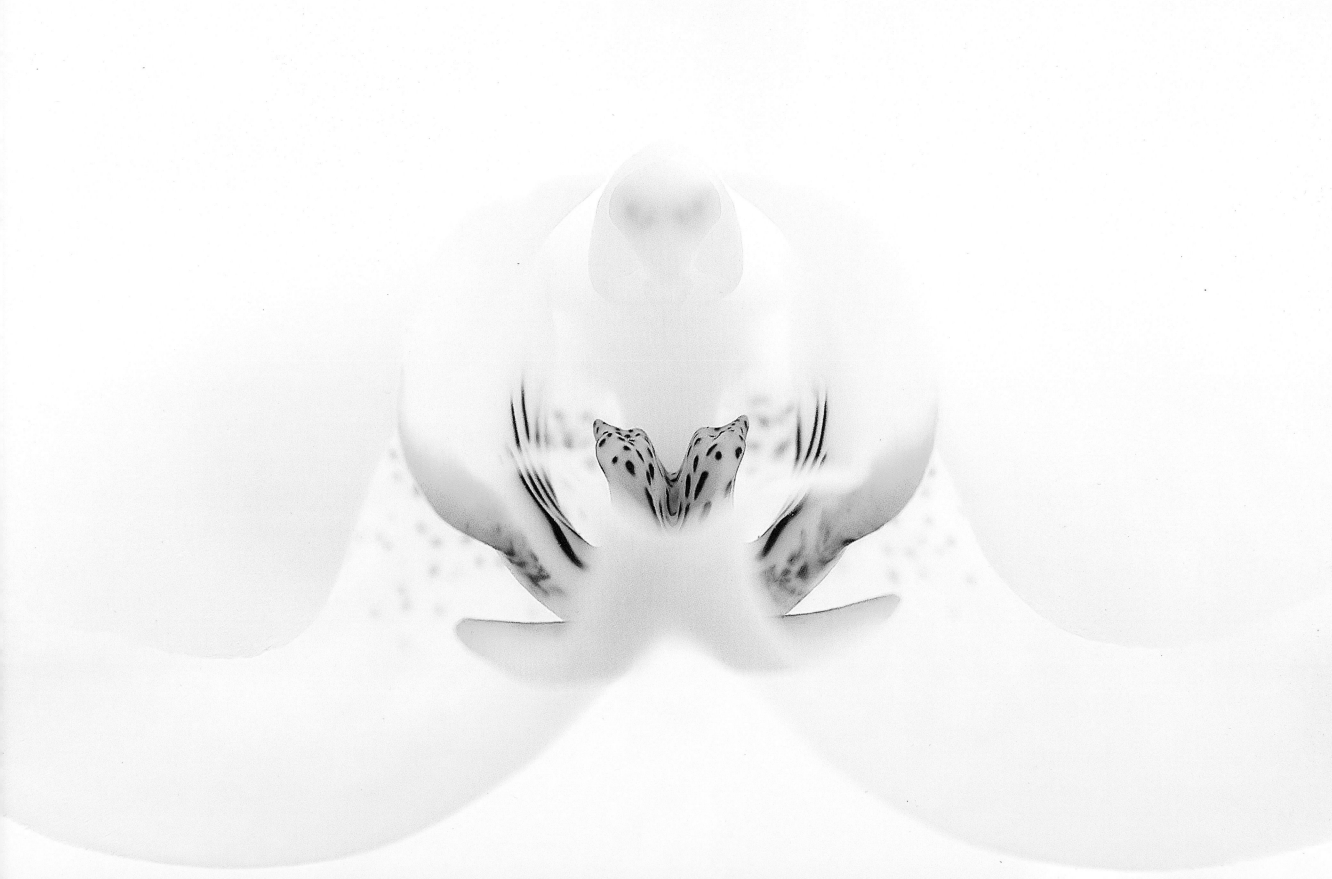